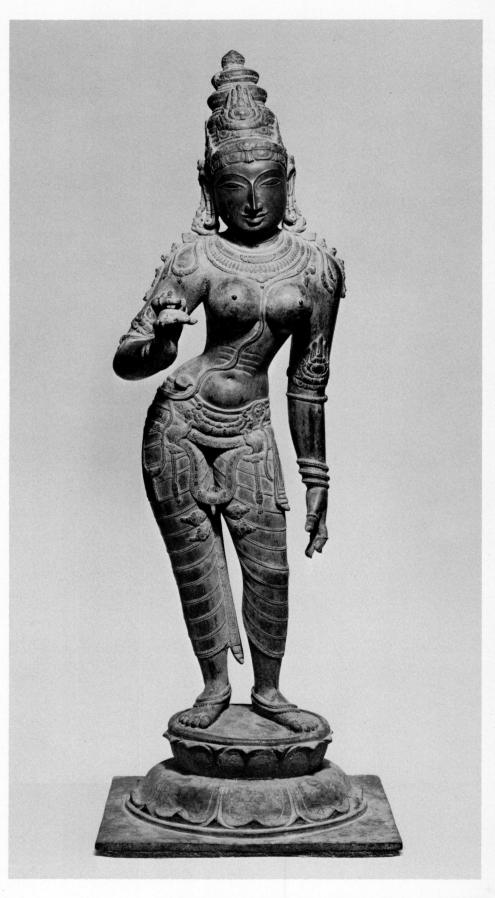

Parvati from Southern India. Bronze. Hindu India, 14th century A.D. Height 31⅛". (Private collection, New York; photo by Helga Photo Studio)

Sculpture of the Orient

HUGO MUNSTERBERG

DOVER PUBLICATIONS, INC., NEW YORK

For Paul Haldeman

A book after his
heart, with lots
of pictures and
few words

ACKNOWLEDGMENTS

This book would not have been possible without the help of the museum curators, collectors, and dealers in Oriental art who generously permitted me to reproduce works in their possession. My special thanks go to Mr. Laurence Sickman of the Nelson Gallery in Kansas City, Mr. John Pope of the Freer Gallery in Washington, D. C., Dr. Stanislaw Czuma of the Brooklyn Museum, Mr. Earl Morse, Dr. Arthur Sackler, and Mr. William Wolff. For the editing of the text and her help in preparing the book for publication, I wish to express, as on so many other occasions, my debt to my wife, Peggy Munsterberg.

H. M.

Published in Canada by General Publishing Company, Ltd., 30 Lesmill Road, Don Mills, Toronto, Ontario.
Published in the United Kingdom by Constable and Company, Ltd., 10 Orange Street, London WC 2.

Sculpture of the Orient is a new work, first published by Dover Publications, Inc., in 1972.

International Standard Book Number: 0-486-20018-3
Library of Congress Catalog Card Number: 72-158731

Manufactured in the United States of America
Dover Publications, Inc.
180 Varick Street
New York, N. Y. 10014

Introduction

The sculpture of Asia, which was all but unknown as recently as the last century, is recognized today as one of the great art traditions of the world. Works which in the nineteenth century were looked upon as little more than pagan idols are now regarded as masterpieces equal to the finest produced by any other civilization. In André Malraux's imaginary museum without walls, the Dancing Shivas from Hindu India take their place beside the statues of Greek gods, the Lung-men Bodhisattvas are seen as similar in spirit to the Romanesque carvings from Vézelay and Autun, the meditating Maitreya figures from Buddhist Japan are experienced as religious icons as moving as those created by the Gothic artists, and the giant smiling Lokesvara heads from Angkor Thom in Cambodia are comparable to the colossal busts of the Emperor Constantine. The reevaluation of Asian sculpture, like that of Africa and ancient America, was the result of the broadening horizons of modern Western man who developed the ability to transcend the parochial limits of his own civilization and to see and experience the full range of the varied artistic and cultural traditions of man.

For their creators, these images did not constitute art in our sense of the word; in fact, the whole idea of producing a work of art primarily for aesthetic enjoyment was all but unknown in the traditional societies of Asia. Their purpose was functional, for they served as religious icons to aid in worship and to decorate the sanctuaries. Art for art's sake, a concept so dear to the modern West, was quite alien to the East, and the naturalistic conventions which originated in ancient Greece and governed Western art from the Renaissance to the end of the nineteenth century were not relevant to the kind of art which the East wished to create. Like the Medieval sculptors of the Christian West, these men did not try to imitate the world of visual appearances. Instead, they attempted to create a new world of images which would express in a more profound way the nature of ultimate reality. As the inscription on a Chinese stele of 520 A.D. says, "Since the divine doctrine is of subtle transcendence, it can be truly manifested only with words and images. Since perfect knowledge is profoundly deep, there is no means of displaying the glorious signs unless with representative figures." To make the invisible manifest, to give embodiment to the spiritual, such was the purpose of this art, and consequently most of it was either religious in nature or connected with the cult of the dead and the superstitions of the living.

As a result of this point of view, the Asians thought of the artist as an accomplished artisan rather than a creative genius. The people who made the images were nothing more than anonymous craftsmen who were admired for their skill in carving wood or stone, modeling clay, or casting bronze. As Coomaraswamy says in his *Transformation of Nature in Art*, "The artist himself

. . . is commonly described as 'knowing his craft' . . . and as 'skilful' . . .; nothing like a special sensibility or natural talent is mentioned, but we find that the moral virtues of ordinary men are expected in the artist, and for the rest he has his art which he is expected to practice. His attitude with respect to his commission is naturally expressed in *Jātaka*, II, 254, as follows: 'We musicians, O king, live by the practice of our art . . .; for remuneration, I will play,' but as numerous texts and inscriptions prove, the workman when moved by piety was ready to work gratuitously as an act of merit."* Little or no emphasis was placed upon originality. What was far more important was to be faithful to the traditions and correct iconographically, and numerous legends tell of the supernatural inspiration which governed the measurement and forms of the sacred images. It is even said of one artist that he traveled to the Tushita Heavens to observe the true forms of the Buddha so that he could represent them accurately in his work. The style of these images did not change much from age to age, for the artists were expected to work in the traditional framework rather than to be original. As a result, it is often difficult to date a given work within a century or two.

The inspiration for this art was largely derived from the two major religions of Asia, Buddhism and Hinduism, both of which originated in India but spread throughout the East. Although other religions, such as Jainism in India, Confucianism and Taoism in China, and Shintoism in Japan, also produced sculpture none of these works equal the numerous images created in the service of the two chief religious systems, one of which was based on the teachings of Buddha and the other on the Vedic Hymns. Purely secular sculpture, which in the West has had a major role ever since the fifteenth century and is completely dominant today, was almost unknown in the traditional East. In India, the only non-religious works were decorative carvings, and even these often used forms which were derived from religious iconography. A secular tradition did exist in China which produced some small-scale sculpture that was purely decorative in function and was not connected with either Buddhism or the native religious traditions. However, the great bulk of sculptures from all over Asia consisted of religious images which were intended for temples and shrines or for private religious devotions. Some of these were believed to possess supernatural powers and were said to have bestowed favors on those who worshipped them. Other works were made to guard holy places and to decorate the gates and exteriors of sanctuaries. Their function was to inspire and instruct the faithful, a purpose much like that of the religious sculptures of Medieval Europe.

Among the many different types of sacred images, the two most remarkable are those of the Buddha and the god Shiva, the one represented as the spiritual sage who has overcome the world and achieved ultimate harmony, and the other portrayed as Nataraja, the Lord of the Dance, whose dynamic forms and multiple limbs represent the supernatural power of the god whose cosmic dance symbolizes the eternal process of the creation and destruction of the universe. These iconographical types both originated in India and then spread throughout the rest of Asia wherever Hinduism and Buddhism were preached. Although their style differs from country to country and even from age to age, the basic conceptions are the same, whether they were made in

*Dover reprint, p. 99.

India, Central Asia, China or Cambodia. Indeed, one can speak of a kind of international Buddhist style, as Okakura did, a style which extended all the way from the Gandhara region of Northwestern India to China, Korea, and Japan as well as to South and Southeast Asia, wherever the influence of Indian thought and culture made itself felt. In fact, the basic types are still being used today. For example, the Buddha and Bodhisattva images, which were evolved almost two thousand years ago in India, are still employed by pious artisans in Buddhist countries, just as the representations of the Hindu gods Brahma, Shiva, and Vishnu, which were created in Gupta India some fifteen hundred years ago, continue to guide the image makers in the Indian villages today.

The earliest phase of **Indian** art, which lasted from the middle of the third millennium to about 1500 B.C., was the Indus Valley or Indo-Sumerian civilization. Although the sculptures from this period are sometimes quite remarkable, they were few in number and small in scale. After the Aryan invaders destroyed the Indus Valley culture, no sculpture was made for over a thousand years. It was not until the third century B.C. under King Ashoka, the great patron of Buddhism, that sculpture began to flourish, and from that period until the seventh century, when Buddhism in India began to decline, a wealth of magnificent sculpture was created, a body of work which constitutes one of the most brilliant creations in world art. During the early phase, the person of the Buddha was never represented. Instead, he was symbolized by emblems such as the wheel, the lotus flower, his throne, or his footprints. Beginning with the first century A.D. under the Kushan dynasty, the Blessed One was represented as a holy monk displaying the marks of the Great Being, such as the Ushnisha (the protuberance on his head) or the Urna (third eye), both of which symbolize his supernatural knowledge. While the earliest of these images was probably derived from late classical Western models, the finest representations of the Buddha, which date from the fourth to the seventh centuries and were made under the Gupta dynasty, are purely Indian in style and inspiration. After the Gupta period, Buddhism and Buddhist art declined in India proper, and only in the eastern sections, such as Bengal and Bihar, and in the adjacent northern countries, especially Nepal and Tibet, did it continue to flourish.

The other major religious and artistic tradition of India is that of Hinduism, a faith based on the ancient Vedic religion of the Aryans. Overshadowed for a time by Buddhism, it underwent a vigorous revival during the Gupta period and by the eighth century, it had become the dominant religion of the Indian subcontinent. A mass of images was produced all over India in which the many gods of the Hindu pantheon were portrayed in animal and human form. The most important were Shiva, the Destroyer, with his divine consort Parvati and their elephant-headed son Ganesha, and Vishnu, the Preserver, with his lovely female counterpart, Lakshmi. These figures, however, were only the most commonly represented among the multitude of deities and sacred beings who were portrayed in countless carvings decorating the surfaces of temples and serving as icons in the sanctuaries. Stone was the favorite material, especially for architectural sculptures, and bronze was also popular, most notably in Southern India under the Chola dynasty, which ruled from the ninth to the thirteenth century. The conquest of Northern India by Moslem invaders put an end to this artistic productivity by the end of the thirteenth

century, but in the South, Hindu art has continued to be made right up to the present day.

From India proper, Buddhism and Buddhist art spread all over Asia as missionaries carried the teachings of Buddha first to neighboring countries like Ceylon and Afghanistan and ultimately to places as distant as Japan and Indo-China. Among the many sculptures produced in the area which the Indologist Heinrich Zimmer calls **Indian Asia,** the earliest were those made in Ceylon and Central Asia, while at a somewhat later period, excellent Buddhist images were also produced in Java, Burma, Thailand, and Cambodia. Of these, the Cambodian carvings created under the Khmer rulers from the tenth to the thirteenth century are considered among the finest sculptures ever made. Although they are based on Indian prototypes, they have their own distinctive characteristics, such as the mysterious smile which hovers over their lips. While the Buddhist art of Java and Central Asia, like that of India, died out many centuries ago and Cambodia has produced no significant work for some time, in other countries of Southeast Asia, notably Thailand, outstanding Buddhist images were still being made as recently as the nineteenth century.

In most of these countries Hinduism either replaced Buddhism or the two existed side by side, as was the case in Cambodia. In fact, some of the greatest of the Cambodian temples were dedicated to Hindu gods who were worshipped along with Buddhist deities. Although the iconographical forms, especially the use of multiple heads and arms, usually distinguish Hindu from Buddhist images, they are very similar in style and both exhibit that wonderful feeling for plastic form which is so characteristic of Cambodian sculpture. Burma and Thailand, which remained Buddhist, did not produce any significant Hindu art, while in Java Buddhist art gave way to the Hindu, which in turn was replaced by Islam some centuries later. Only on the island of Bali has traditional Hindu art survived to the present day. In Ceylon, Buddhist and Hindu art existed side by side for many centuries, but both traditions eventually lost all vitality.

The most important countries in Eastern Asia are China and Japan, both of which have produced outstanding works of sculpture. In ancient **China,** the most significant art was the ceremonial vessels, many of which were very sculptural in form. Although some small-scale carvings and bronze figures were produced in Shang and Chou times, monumental sculpture as a major art form dates from the Han period, which lasted from the second century B.C. to the second century A.D. Favorite subjects were horses, dragons, and various types of people, the latter often clay figurines which were buried in the tombs with the dead.

With the introduction of Buddhism in the early centuries of the Christian era, Indian Buddhist art completely transformed the Chinese sculptural tradition. By the fifth century, China had become a Buddhist country. As a result, most of the sculpture produced over the next thousand years was largely Buddhist in character following the iconographic forms imported from India. The earliest images also resembled the Indian ones in style, but over the centuries they became increasingly Chinese. A great variety of artistic media were used, with stone, bronze, and wood the most common. The finest images, like the sculptures at the great cave temples of Northern China and the many gilded statues, were made during the Wei and T'ang dynasties between the fifth and ninth centuries. After this a decline set in, although

beautiful wooden carvings were still produced in the Sung period as late as the twelfth and thirteenth centuries.

Closely related to the sculptural tradition of China was that of **Korea,** which produced some outstanding Buddhist images during the sixth and seventh centuries under the Silla dynasty. From Korea, Buddhist art was introduced to **Japan,** where, prior to this, the only sculptures produced were small clay female idols and hollow cylindrical grave figures known as Haniwa. Under the influence of Buddhism, sculpture in Japan flourished, with the Japanese soon rivaling and at times even surpassing their Korean and Chinese teachers. Unlike China, where stone had been the favorite medium, the Japanese preferred wood, although they also made statues of bronze, lacquer, and clay. The most creative phase of Japanese Buddhist sculpture took place during the Asuka and Nara periods in the seventh and eighth centuries, but outstanding work was also produced at later times. The early images are quite similar to those of Korea and China and since many of the prototypes on which they were based have not survived, these Japanese statues are invaluable for our knowledge of early Buddhist sculpture on the continent. With the advent of the Heian period, the sculpture became more Japanese in style. The most outstanding of the later works, especially the ones produced during the thirteenth century in the Kamakura period, are ranked among the best of all Japanese sculpture. Among the most remarkable are the guardian figures, which are sometimes colossal in size and often excel in dramatic feeling. In Japan as in China, the vitality and expressive power of Buddhist art had declined by the fifteenth century, and today what sculpture there is reflects the various schools of modern Western art.

Bibliography

INDIAN SCULPTURE

Bachhofer, L.: *Early Indian Sculpture,* New York, 1929.
Barrett, D.: *Early Chola Bronzes,* Bombay, 1965.
Cohn, W.: *Indische Plastik,* Berlin, 1929.
Frederic, L.: *Indian Temples and Sculpture,* London, 1959.
Gangoly, O. C.: *South Indian Bronzes,* London, 1915.
Gordon, A.: *Tibetan Religious Art,* New York, 1952.
Kramrisch, S.: *The Art of Nepal,* New York, 1964.
Munsterberg, H.: *The Art of India and Southeast Asia,* New York, 1970.
Pal, P.: *The Art of Tibet,* New York, 1969.
Rowland, B.: *The Art and Architecture of India,* rev. ed., London, 1967.
Sivaramamurti, C.: *South Indian Bronzes,* Bombay, 1963.
Spink, W.: *Ajanta to Ellora,* Ann Arbor, 1969.
Zimmer, H.: *The Art of Indian Asia,* New York, 1960.

SOUTHEAST ASIAN SCULPTURE

Boisselier, J.: *La statuaire khmère et son évolution*, Saigon, 1955.
Coedes, G.: *Bronzes khmers*, Paris, 1923.
Coomaraswamy, A.: *Bronzes of Ceylon*, Kolombo, 1914.
Dupont, P.: *La statuaire pré-angkorienne*, Ascona, 1955.
Giteau, M.: *Khmer Sculpture and the Angkor Civilization*, New York, 1965.
Griswald, A. B.: *Dated Buddha Images from North Siam*, Ascona, 1957.
Groslier, B. P.: *La sculpture khmère ancienne*, Paris, 1925.
Kempers, A. J. B.: *Ancient Indonesian Art*, Cambridge, 1959.
Lee, S.: *Ancient Cambodian Sculpture*, New York, 1969.
LeMay, R.: *A Concise History of Buddhist Art in Siam*, Cambridge, 1938.
Wagner, F. A.: *Indonesia*, New York, 1960.

CHINESE SCULPTURE

Ashton, L.: *An Introduction to the Study of Chinese Sculpture*, London, 1925.
Fischer, O.: *Chinesische Plastik*, Munich, 1948.
Glaser, K.: *Ostasiatische Plastik*, Berlin, 1925.
Matsubara, S.: *Study of Chinese Buddhist Sculpture*, Tokyo, 1961 (in Japanese).
Mizuno, S.: *Bronze and Stone Sculpture of China*, Tokyo, 1960.
—— and Nagahiro: *Yün-Kang*, Kyoto, 1952–1959 (in Japanese with English summary).
Munsterberg, H.: *The Art of the Chinese Sculptor*, Tokyo and Rutland, Vt., 1960.
——: *Chinese Buddhist Bronzes*, Tokyo and Rutland, Vt., 1967.
Priest, A.: *Chinese Sculpture in the Metropolitan Museum*, New York, 1944.
Sickman, L., and A. Soper: *Art and Architecture of China*, London, 1956.
Sirén, O.: *Chinese Sculpture from the Fifth to the Fourteenth Century*, London, 1925.
Soper, A.: *Literary Evidence for Early Buddhist Art in China*, Ascona, 1959.

JAPANESE SCULPTURE

Kidder, J. E.: *Masterpieces of Japanese Sculpture*, Tokyo and Rutland, Vt., 1961.
Kuno, T.: *A Guide to Japanese Sculpture*, Tokyo, 1963.
Munsterberg, H.: *The Arts of Japan*, Tokyo and Rutland, Vt., 1957.
Noma, S.: *Haniwa*, New York, 1960.
Paine, R., and A. Soper: *Art and Architecture of Japan*, London, 1955.
Rosenfield, J.: *Japanese Art of the Heian Period*, New York, 1967.
Staff of the Tokyo National Museum: *Pageant of Japanese Art, Vol. III: Sculpture*, Tokyo, 1952.
Warner, L.: *Japanese Sculpture of the Suiko Period*, New Haven, 1923.
——: *The Craft of the Japanese Sculptor*, New York, 1936.
——: *The Sculpture of the Tempyo Period*, Cambridge, 1959.
With, K.: *Buddhistische Plastik in Japan*, Vienna, 1922.

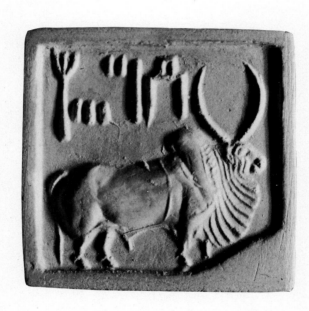

Seal depicting a zebu. Steatite. Indus Valley civilization, 3rd millennium B.C. Height 1¼". (National Museum of India, New Delhi)

Buddhist reliquary. Gold. Buddhist India, 2nd century A.D.
Height 2¾". (British Museum, London)

2 India (Buddhist)

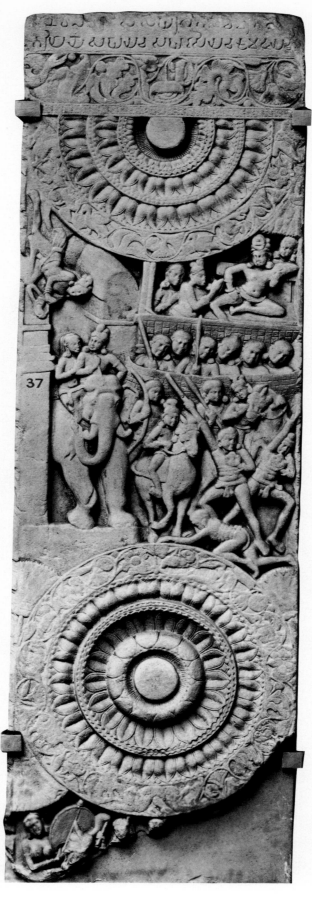

Buddhist scene from Amaravati. Limestone. Buddhist India, 2nd century A.D. Height 59". (British Museum, London; photo by Larkin Bros. Ltd.)

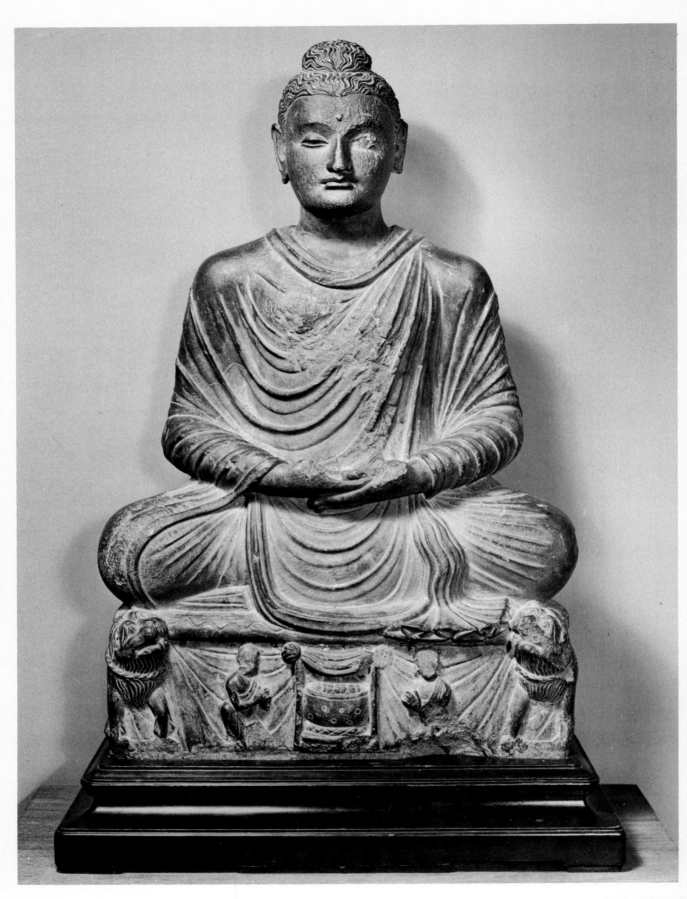

Seated Buddha from Gandhara. Schist. Buddhist India, 2nd century A.D. Height 25". (Wellesley College Museum; photo by Barney Burstein)

4 India (Buddhist)

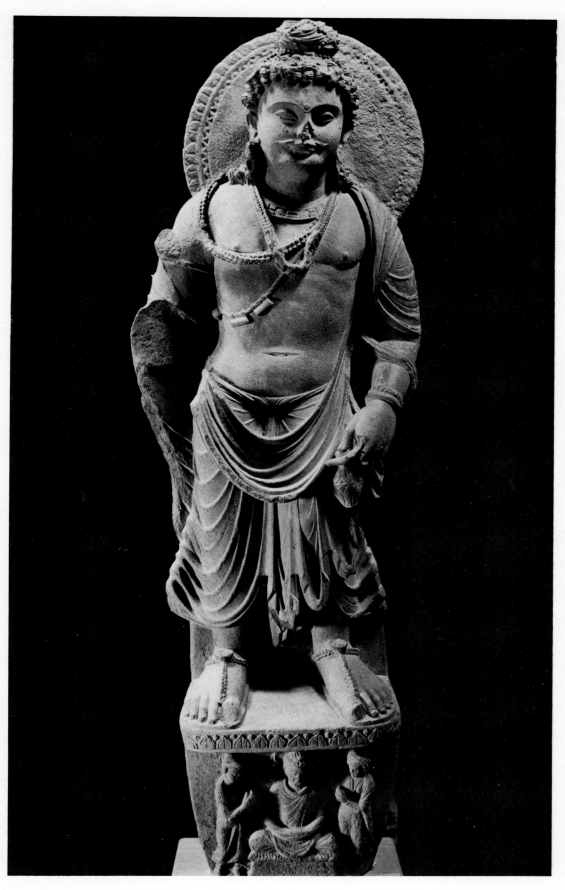

Standing Bodhisattva. Schist. Buddhist India, 2nd century A.D.
Height 32½". (Eisenberg Collection, New York)

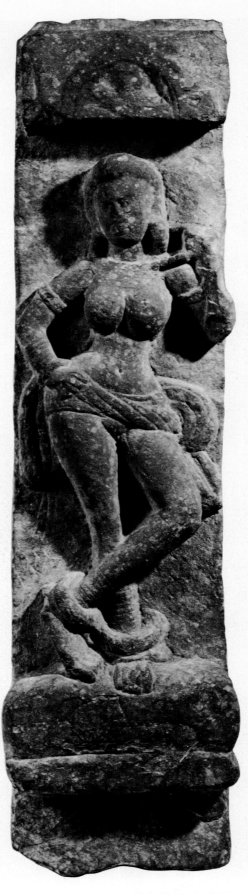

Yakshi from Mathura. Sandstone. Buddhist India, 2nd century A.D. Height 7⅛". (Doris Wiener Collection, New York; photo by Ferdinand Boesch)

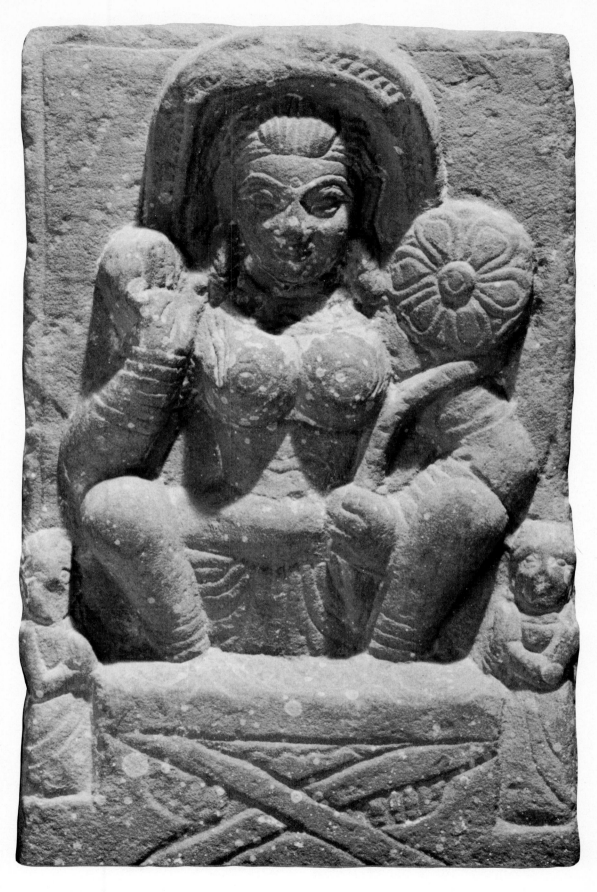

Female deity from Mathura. Sandstone. Buddhist India, 3rd century A.D. Height 9". (Munsterberg Collection, New Paltz, N.Y.; photo by Raphael Warshaw)

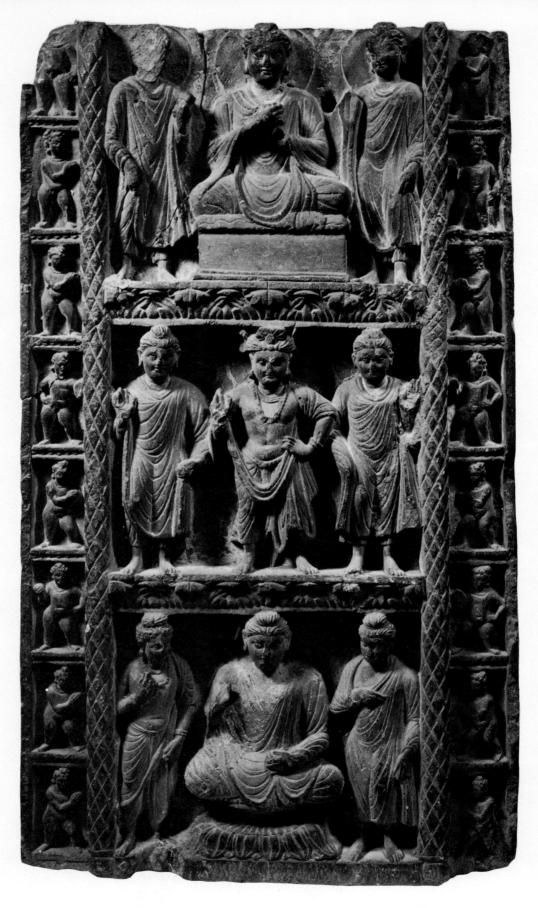

Buddhist relief from Gandhara. Schist. Buddhist India, 3rd century A.D. (Private collection, New York; photo by Thomas Feist)

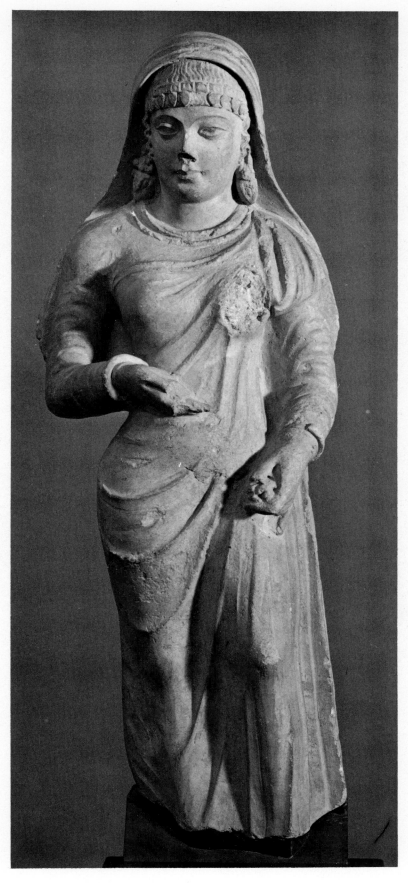

Female figure from Tash Kurgan. Stucco. Buddhist India, 4th century A.D. Height 25¾". (Wellesley College Museum; photo by Barney Burstein)

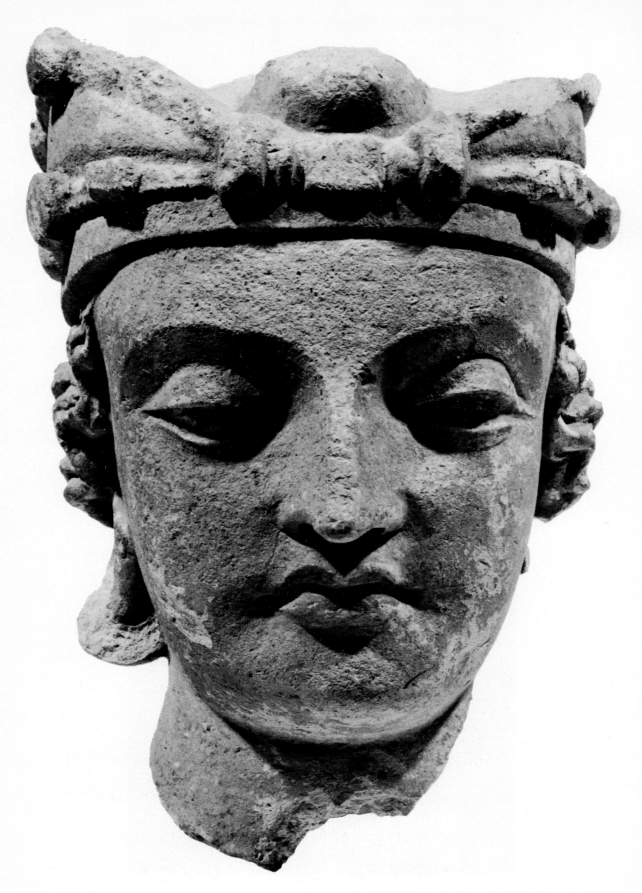

Head of a Bodhisattva. Stucco. Buddhist India, 5th century A.D. Height 8". (Chait Collection, New York)

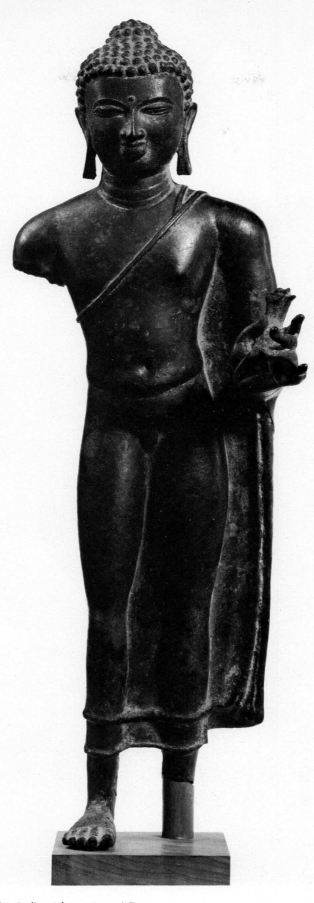

Standing Buddha. Bronze. Buddhist India, 5th century A.D.
Height 19⅞". (Museum of Fine Arts, Boston)

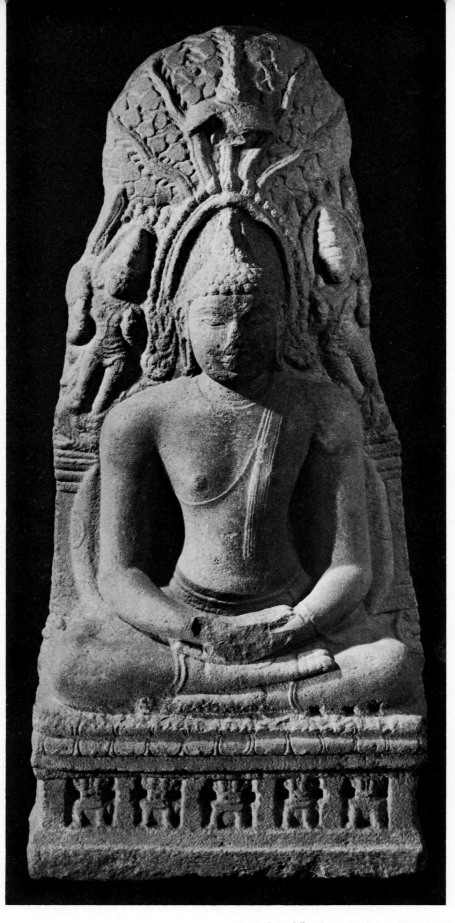

Seated Buddha from Tanjore. Limestone. Buddhist India, 8th century A.D. Height 71". (Boney Collection, Tokyo)

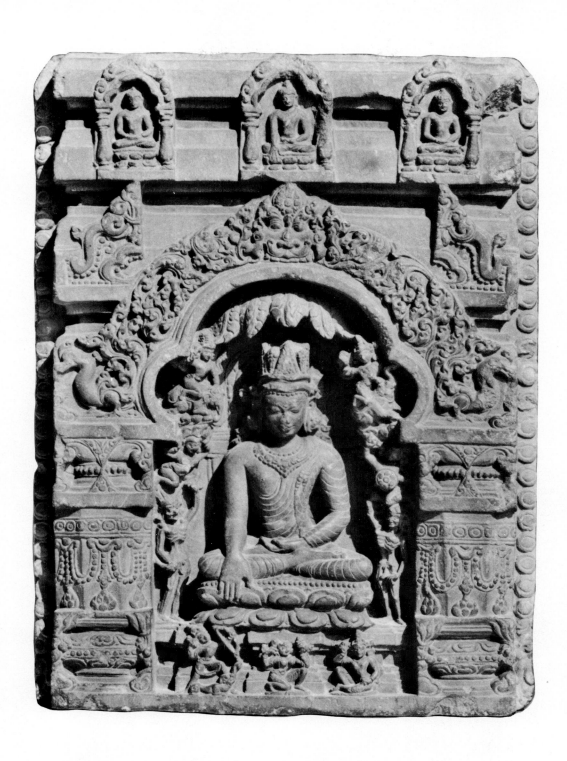

Buddha from Bengal. Basalt. Buddhist India, 11th century A.D.
Height 18½". (Museum für Völkerkunde, Munich)

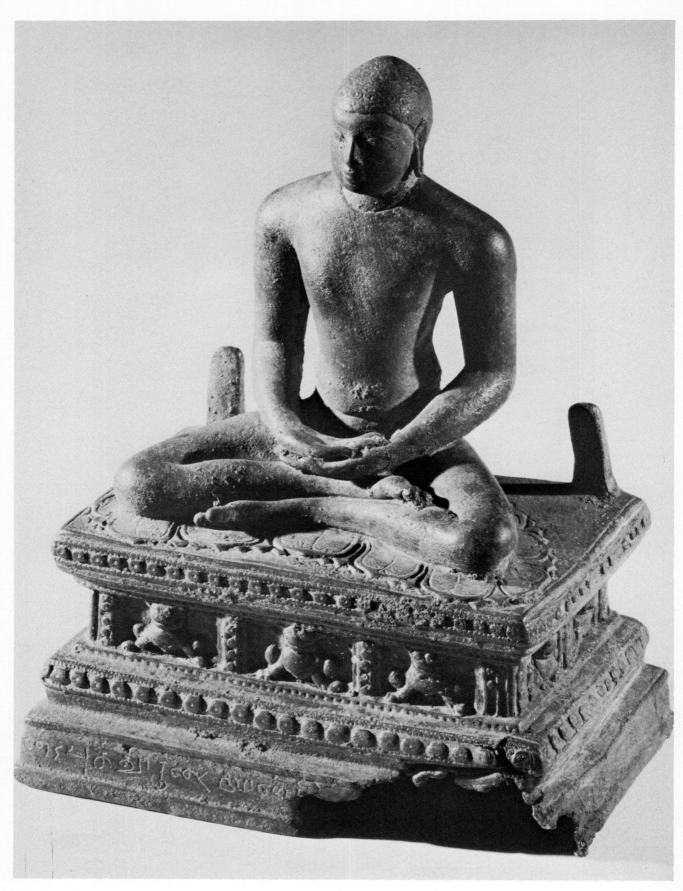

Seated figure of Jina. Bronze. Jain India, 11th century A.D. Height 6". (Sackler Collection, New York; photo courtesy of The Brooklyn Museum)

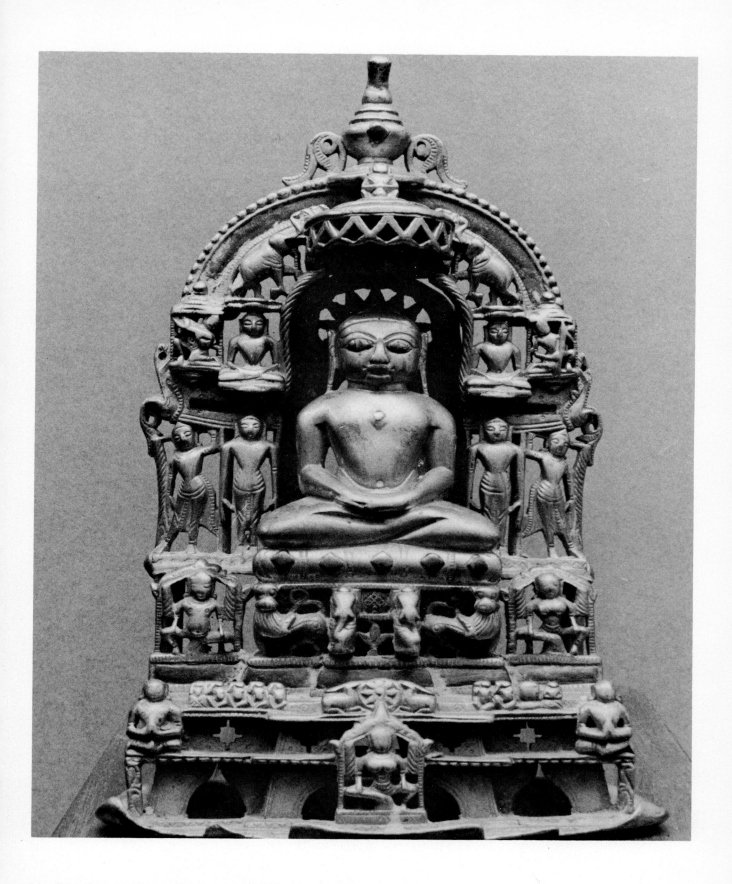

Jain shrine from Northern India. Brass inlaid with silver. Jain India, 14th century A.D. Height 7⅞''. (Private collection, U.S.)

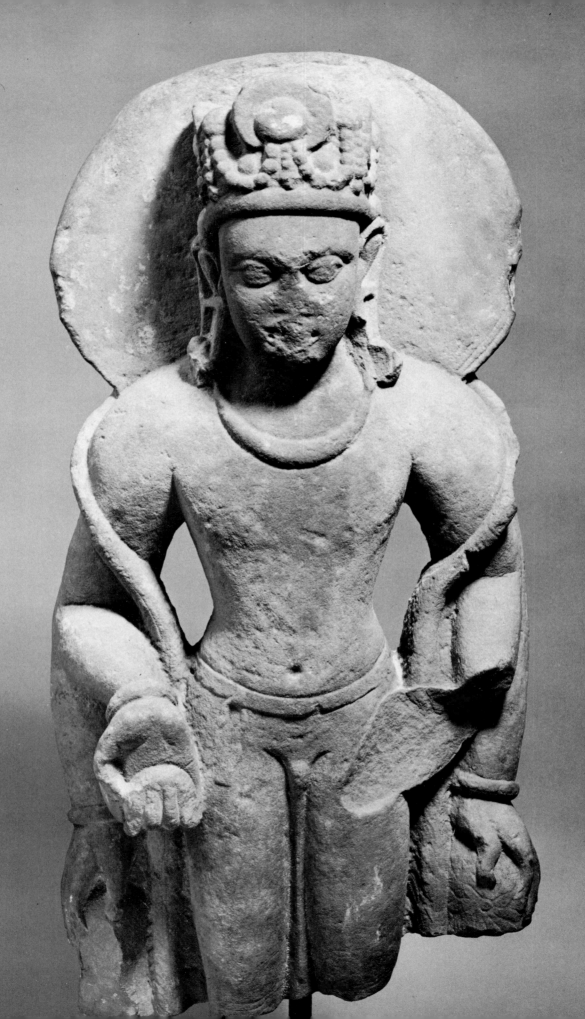

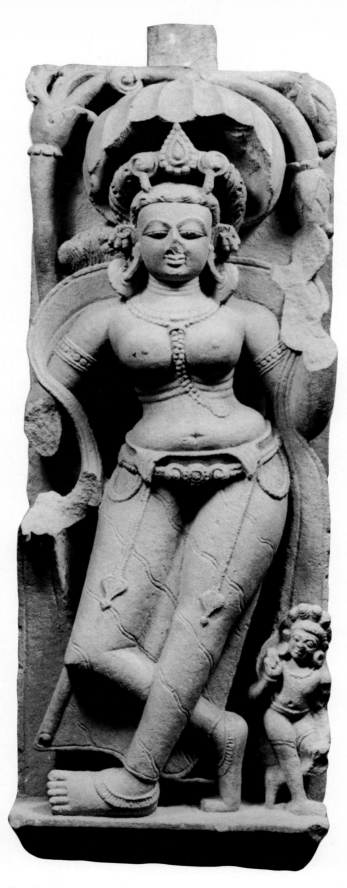

Female figure from Central India. Sandstone. Hindu India, 8th century A.D. Height 32". (William Wolff Collection, New York)

Opposite: Vishnu from Mathura. Sandstone. Hindu India, 5th century A.D. Height 31". (Doris Wiener Collection, New York; photo by Charles Uht)

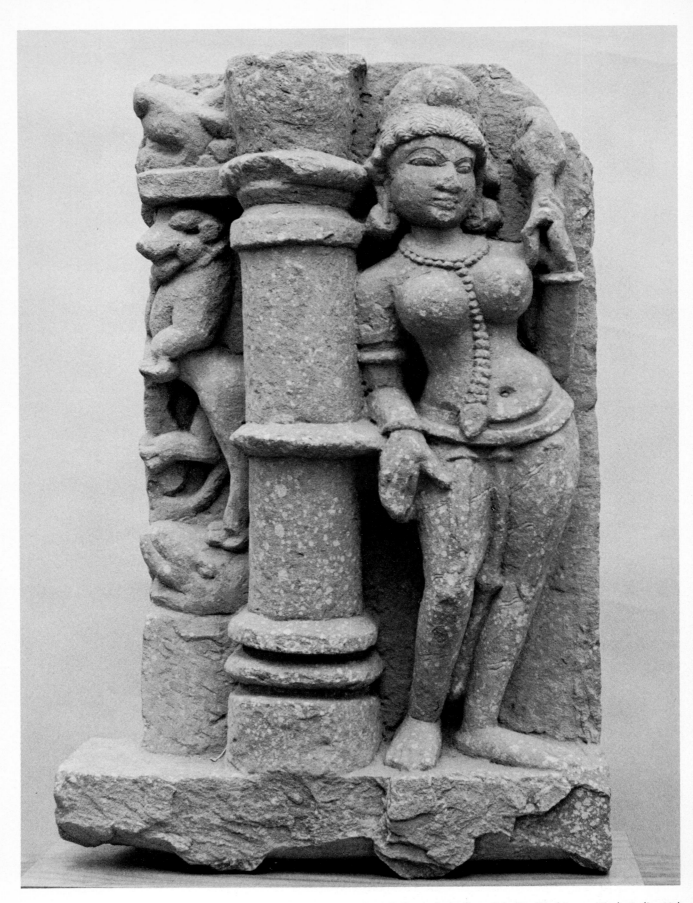

Female figure from Central India. Sandstone. Hindu India, 10th century A.D. Height 26½″. (William Wolff Collection, New York)

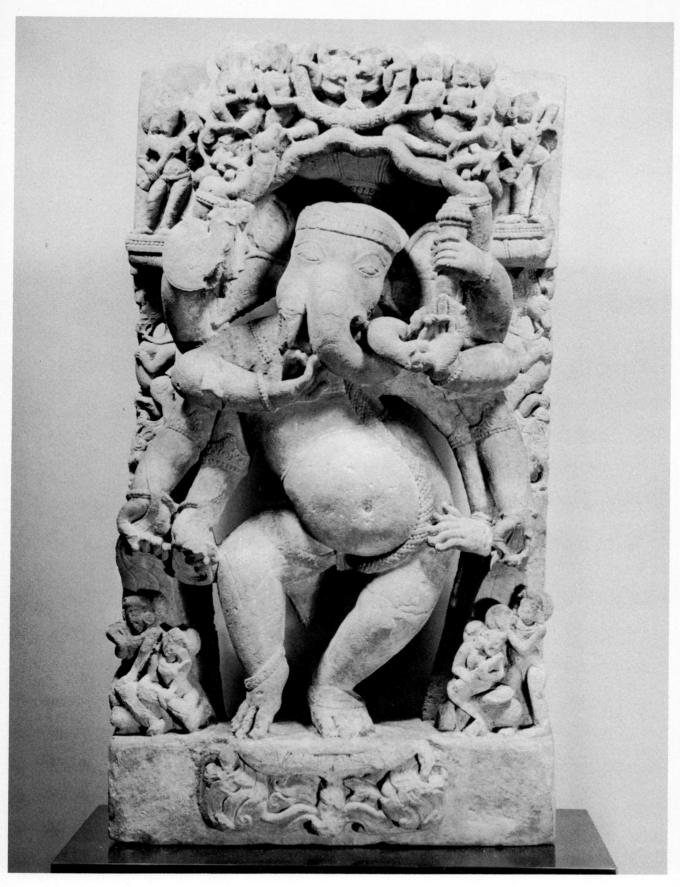

*Dancing Ganesha from Rajasthan. Sandstone. Hindu India,
11th century A.D. Height 39''. (William Wolff Collection,
New York)*

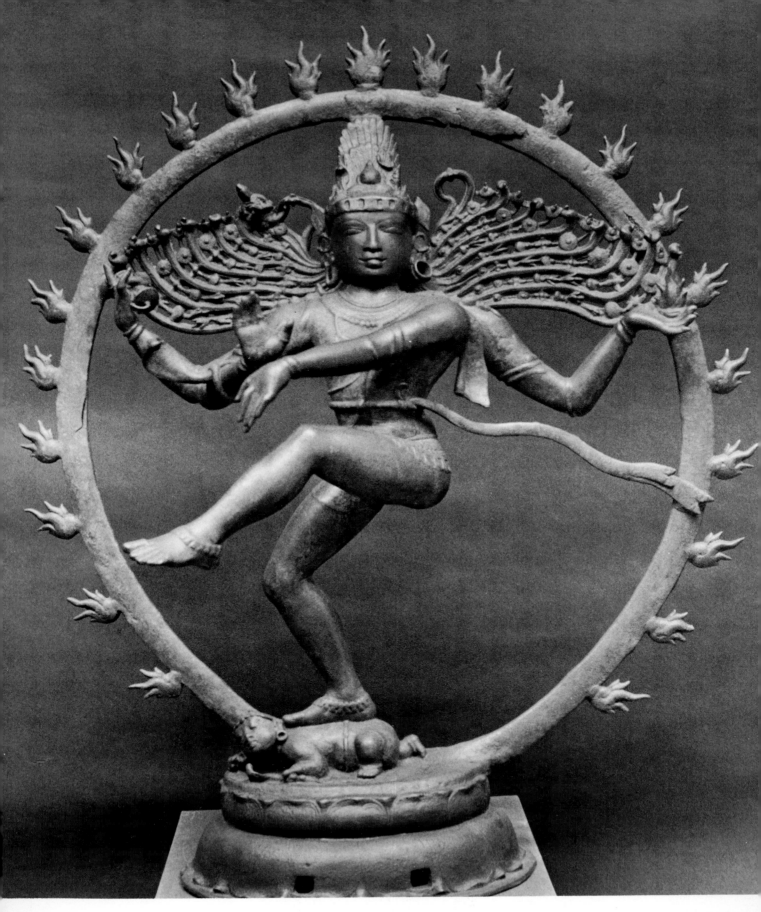

Dancing Shiva from Southern India. Bronze. Hindu India, 10th century A.D. Height 35¼". (William Wolff Collection, New York)

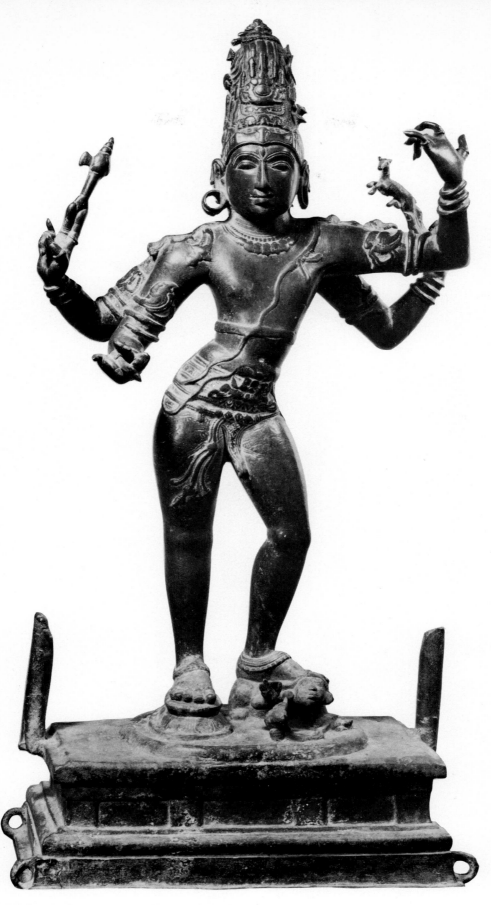

Tripurantaka from Southern India. Bronze. Hindu India, 11th century A.D. Height 35". (William Wolff Collection, New York; photo by O. E. Nelson)

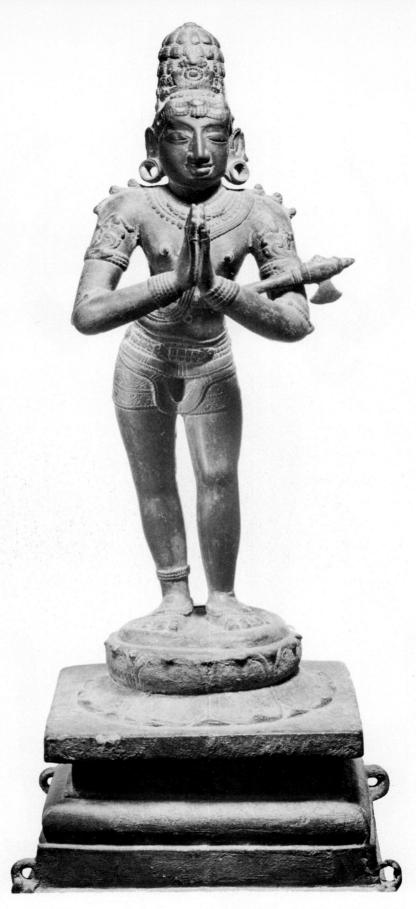

Chandikesvara from Southern India. Bronze. Hindu India, 11th century A.D. Height 23". (Private collection, New York; photo by O. E. Nelson)

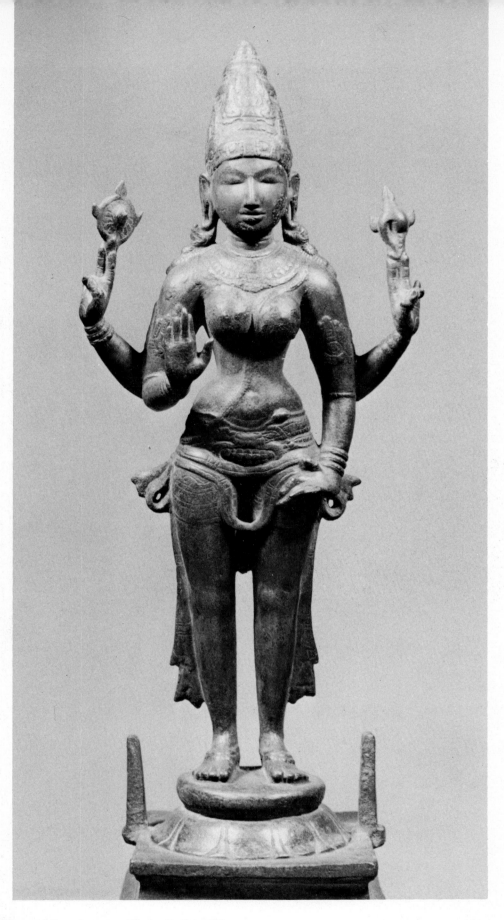

Durga from Southern India. Bronze. Hindu India, 11th century A.D. Height 22½″. (Private collection, New York)

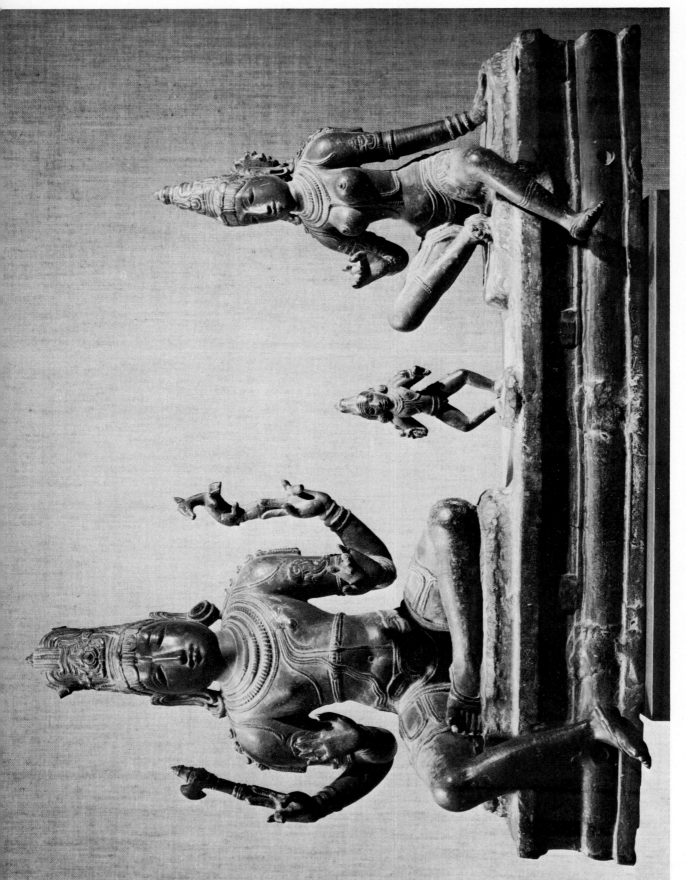

Somaskanda from Southern India. Bronze. Hindu India, 12th century A.D. Height 18½". (Doris Wiener Collection, New York; photo by Charles Uht)

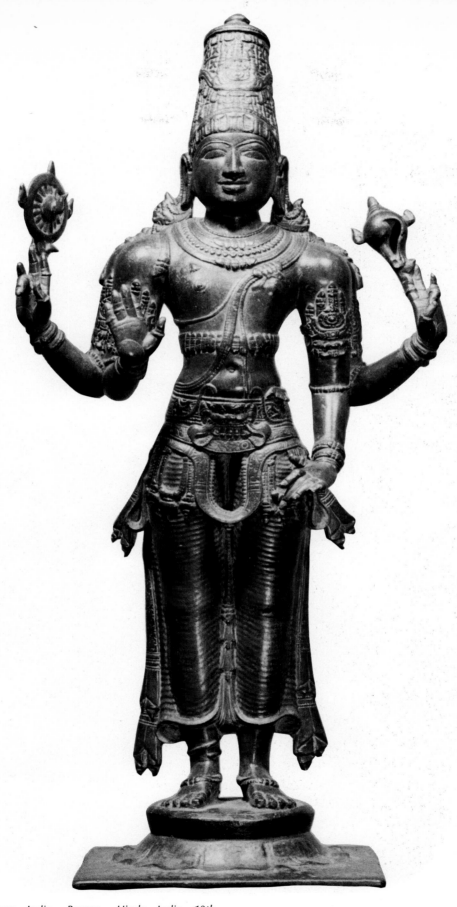

Vishnu from Southern India. Bronze. Hindu India, 12th century A.D. Height 19½". (Private collection, New York)

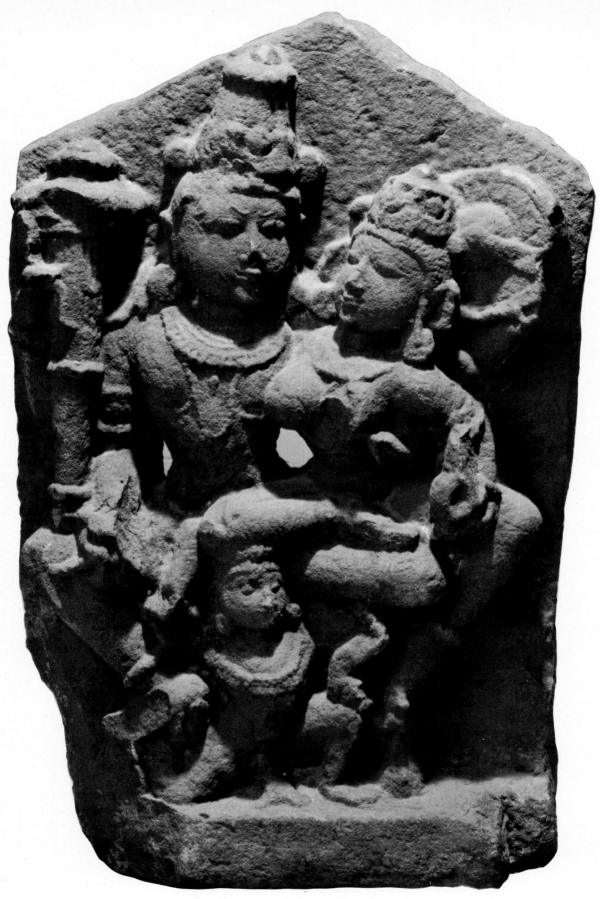

Shiva and Parvati. Sandstone. Hindu India, 12th century A.D.
Height 20". (Munsterberg Collection, New Paltz, N. Y.; photo
by Raphael Warshaw)

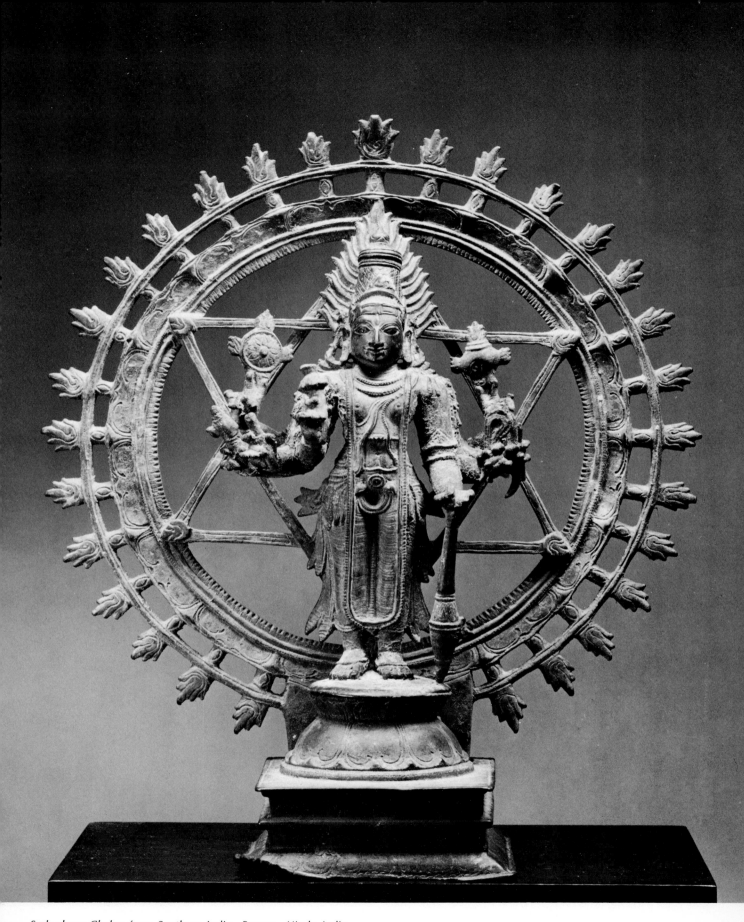

Sudarshana Chakra from Southern India. Bronze. Hindu India, 15th century A.D. Height 10½". (William Wolff Collection, New York; photo by O. E. Nelson)

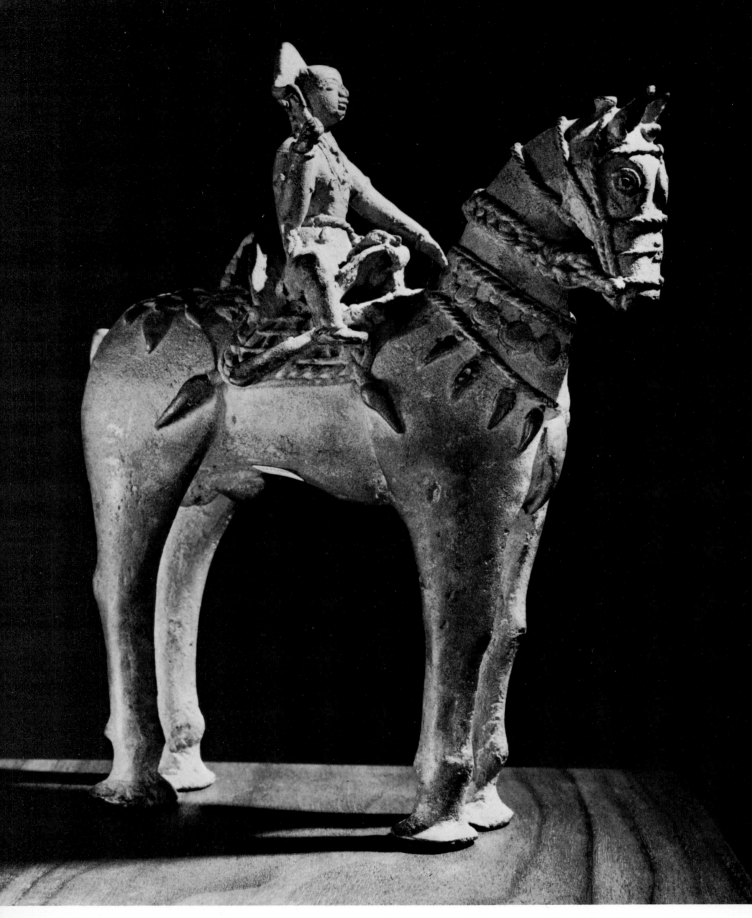

Equestrian figure from Southern India. Bronze. Hindu folk art, 16th century A.D. Height 10⅝". (William Wolff Collection, New York)

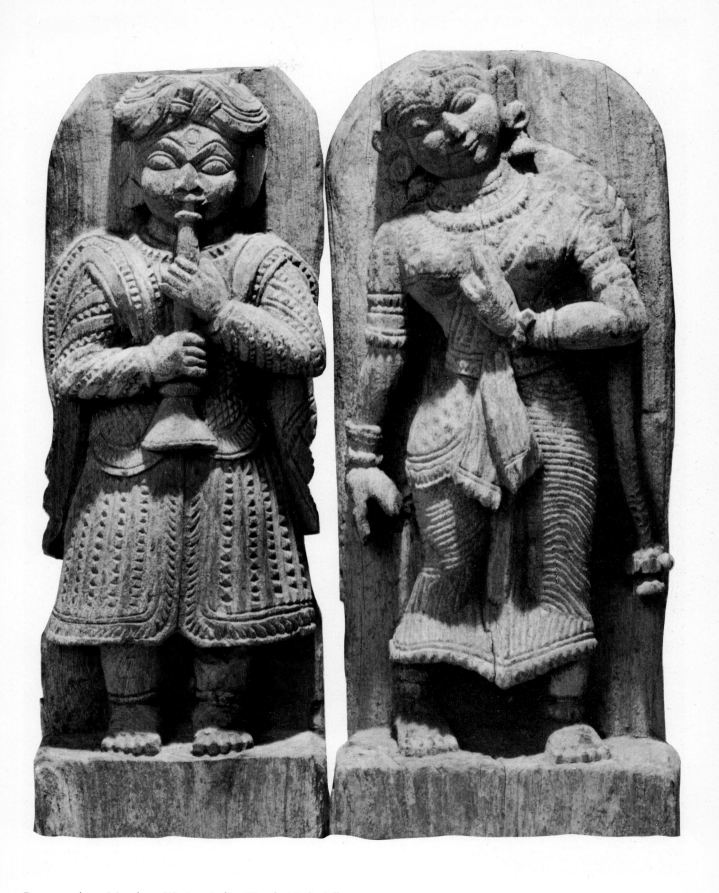

Dancer and musician from Western India. Wood. Hindu folk art, 18th century A.D. Height 34". (Munsterberg Collection, New Paltz, N. Y.; photo by Raphael Warshaw)

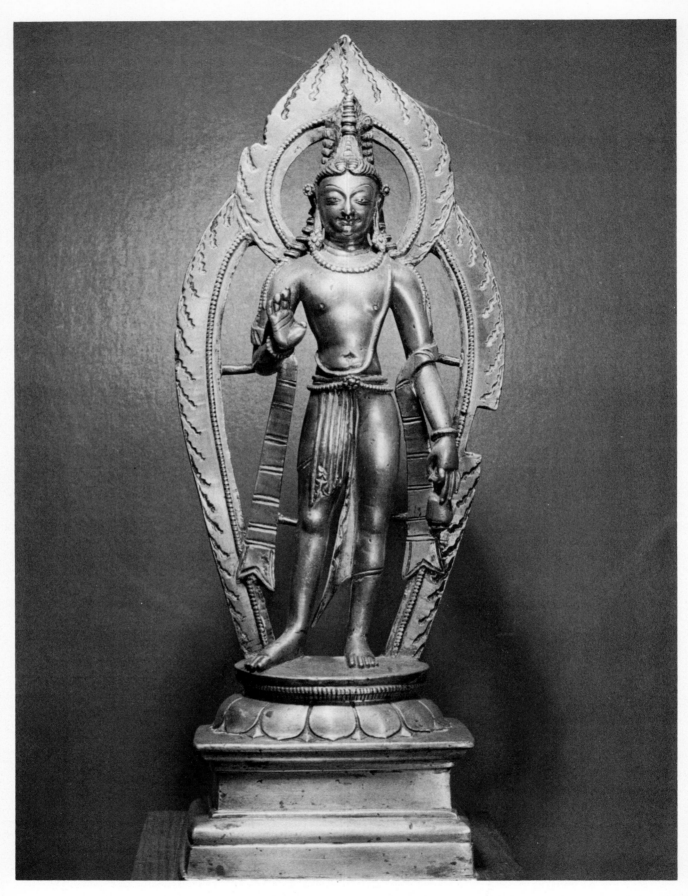

Bodhisattva Maitreya from Kashmir. Bronze. Buddhist India, 8th century A.D. Height 15¼". (Private collection, New York)

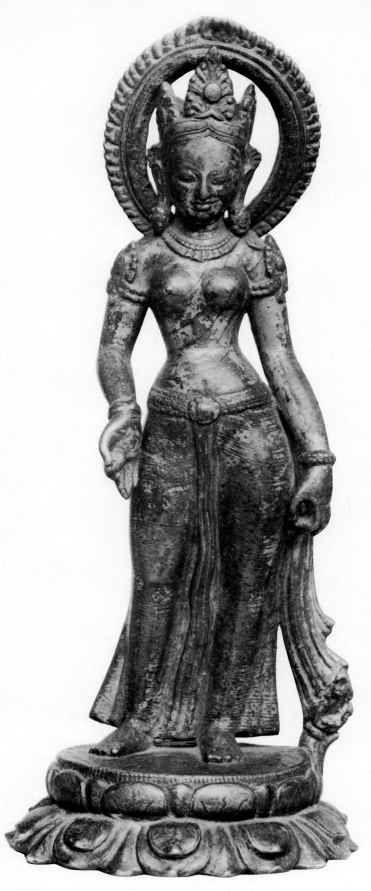

Tara. Gilt bronze. Nepal, 14th century A.D. Height 10½".
(British Museum, London)

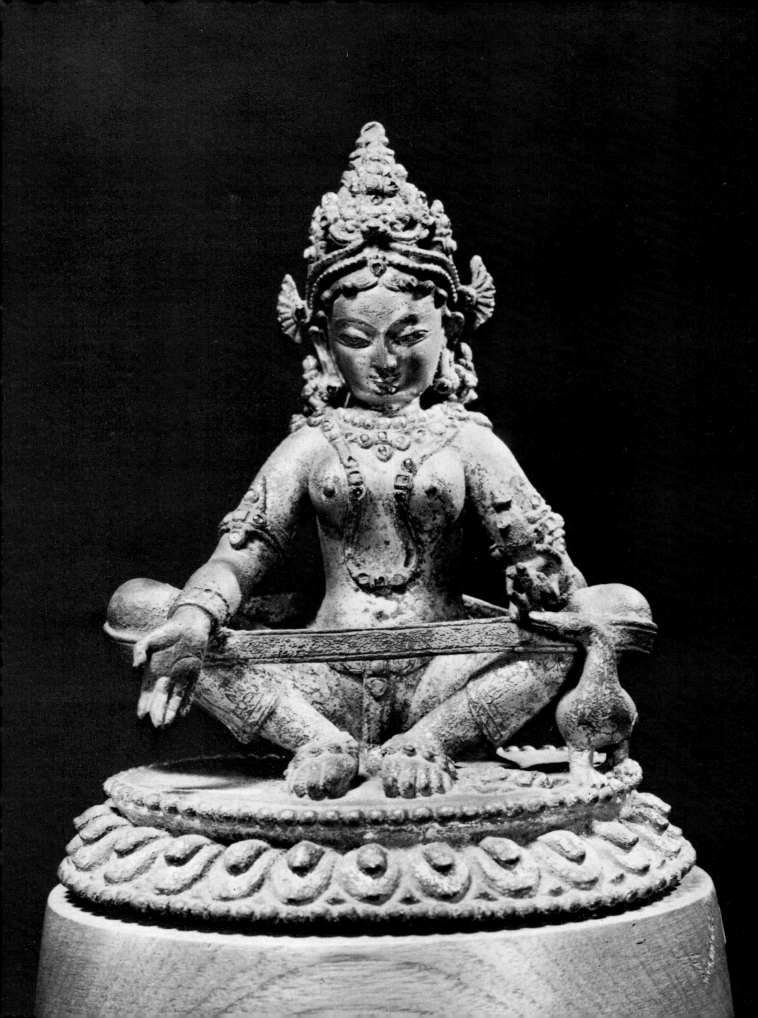

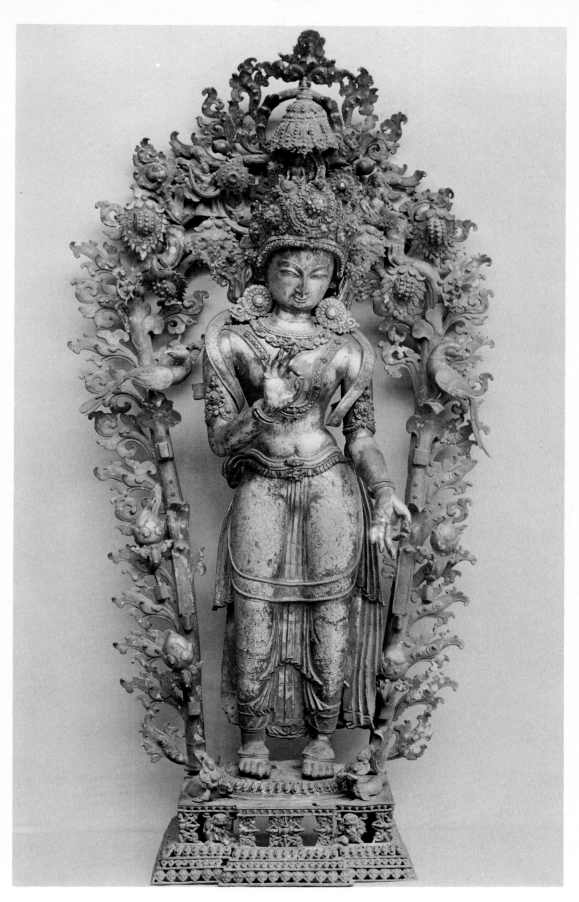

Standing Tara. Gilt bronze. Nepal, 17th century A.D. Height
48½''. (Metropolitan Museum of Art, New York)
Opposite: Seated Tara. Gilt bronze. Nepal, 15th century A.D.
Height 7''. (Private collection, New York)

Nepal 33

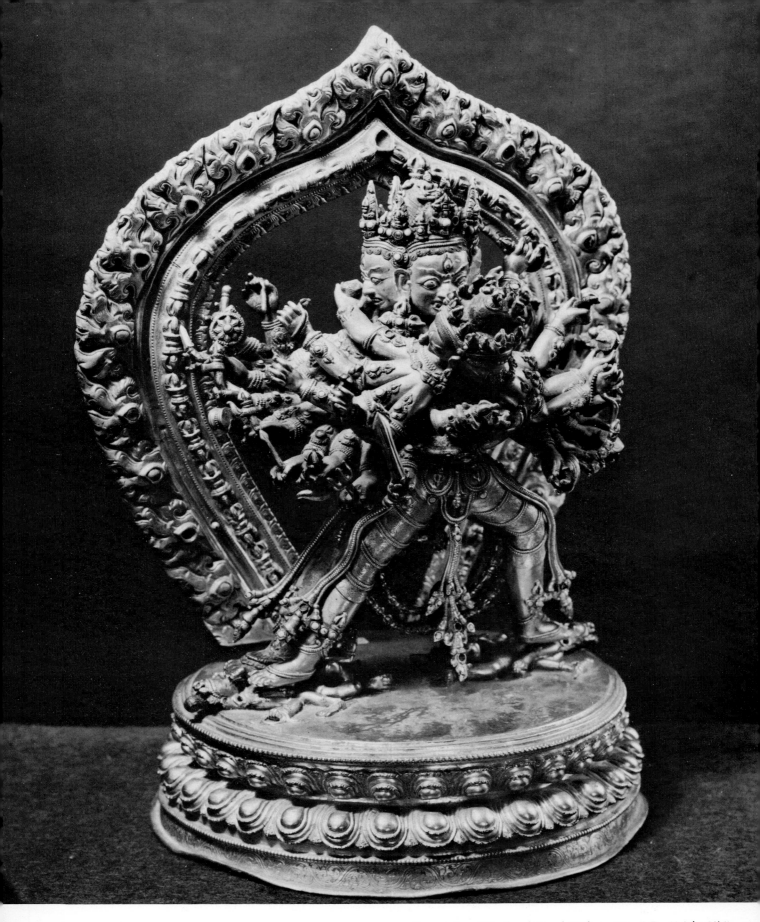

Yamantaka. Gilt silver. Nepal, 17th century A.D. Height 8½".
(William Wolff Collection, New York)

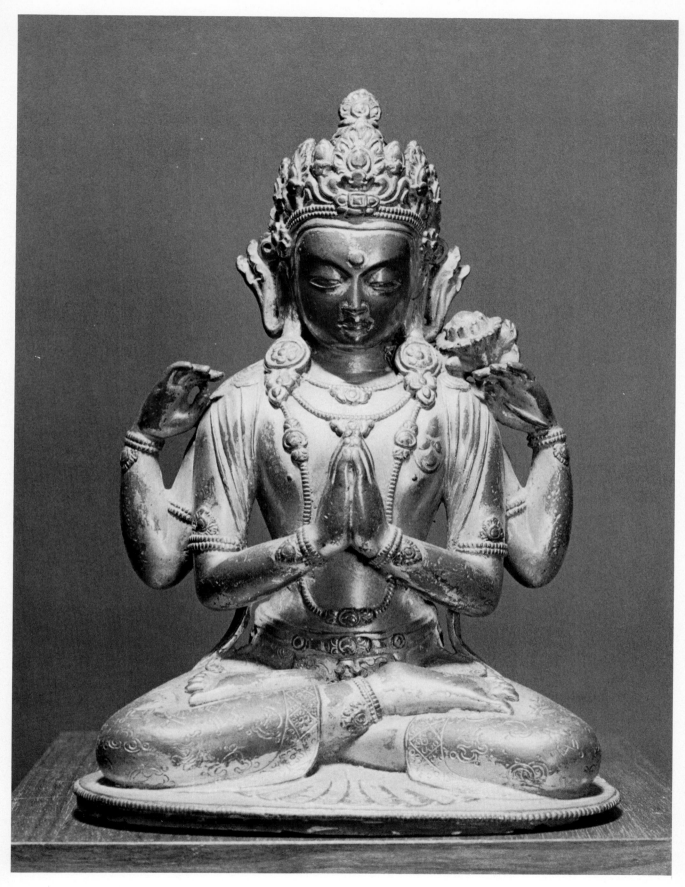

Seated Avalokitesvara. Gilt bronze. Tibet, 16th century A.D.
Height 7". (Private collection, New York)

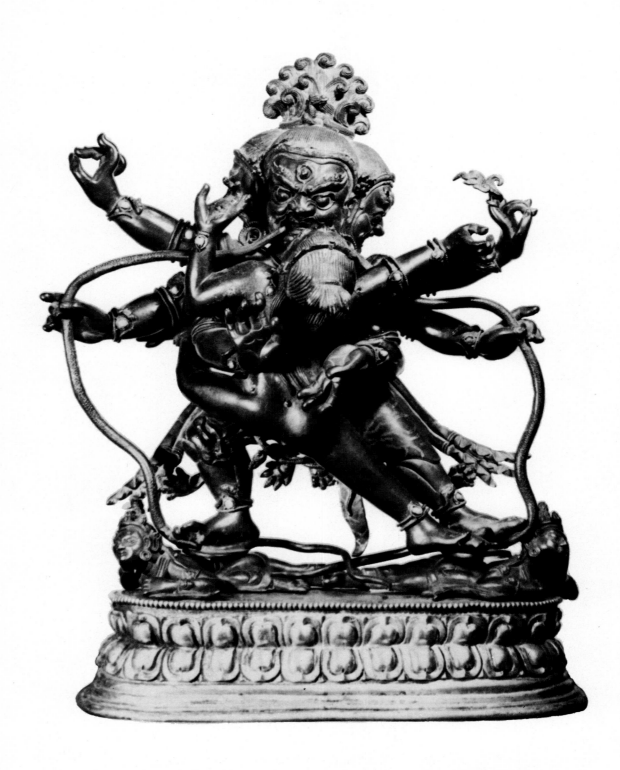

Vajrapani. Gilt bronze. Tibet, 17th century A.D. Height 6½".
(Canella Collection, Ferrara)
Opposite: Seated Padmapani. Gilt bronze. Tibet, 17th century
A.D. Height 9⅝". (Metropolitan Museum of Art, New York)

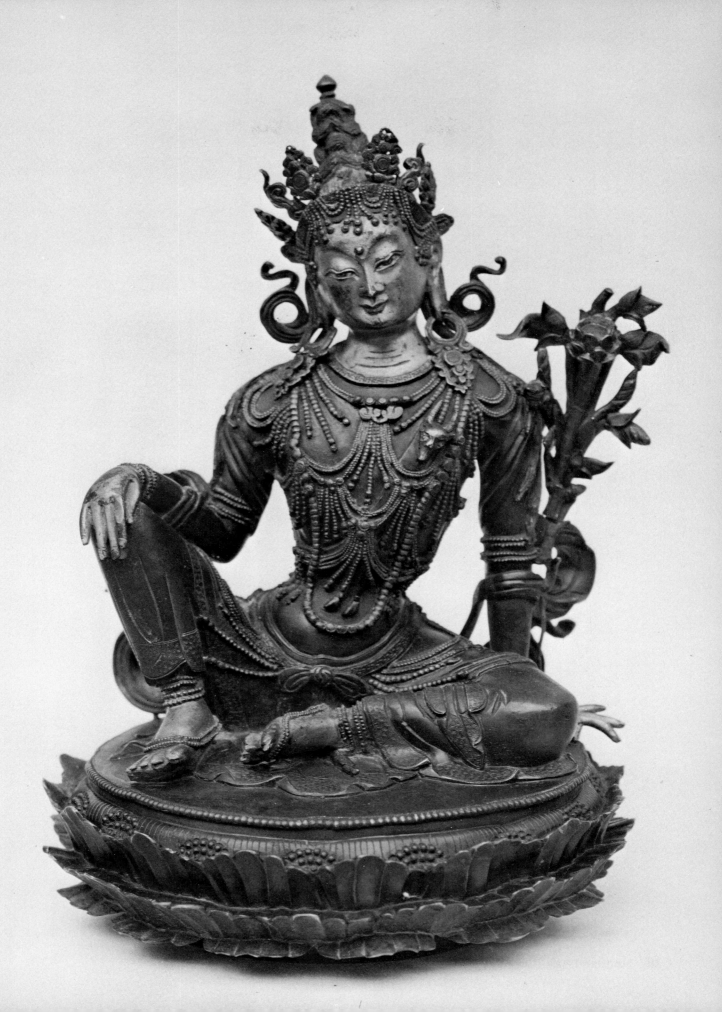

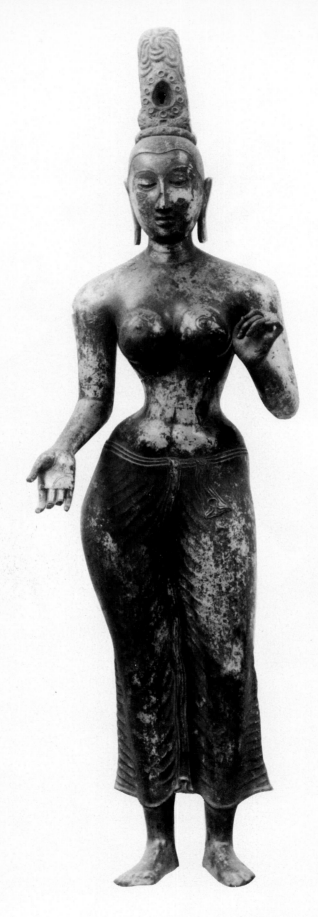

Tara. Gilt bronze. Ceylon, 10th century A.D. Height 57".
(British Museum, London)

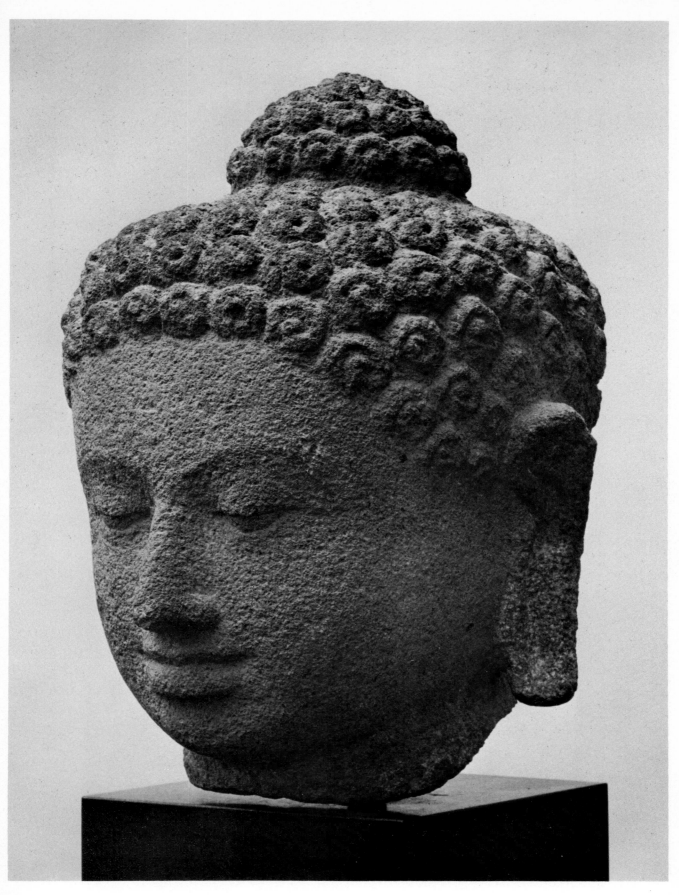

Head of Buddha from Borobudur temple, Java. Volcanic stone.
Indonesia, 8th century A.D. Height 13¾". (William Wolff
Collection, New York; photo by O. E. Nelson)

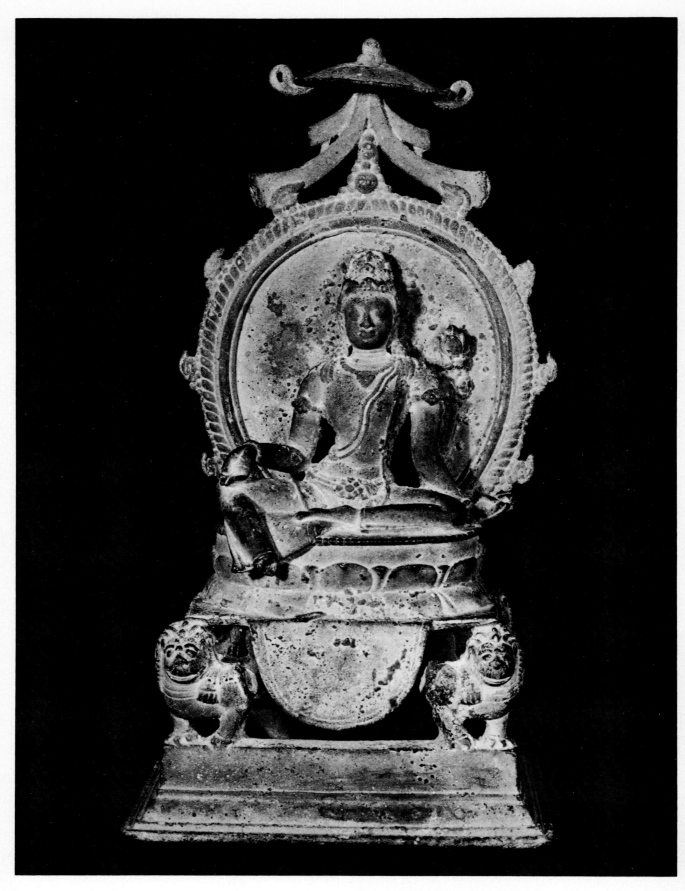

Seated Padmapani from Java. Bronze. Indonesia, 9th century A.D. Height 12¾". (Boney Collection, Tokyo)

40 Southeast Asia (Indonesia)

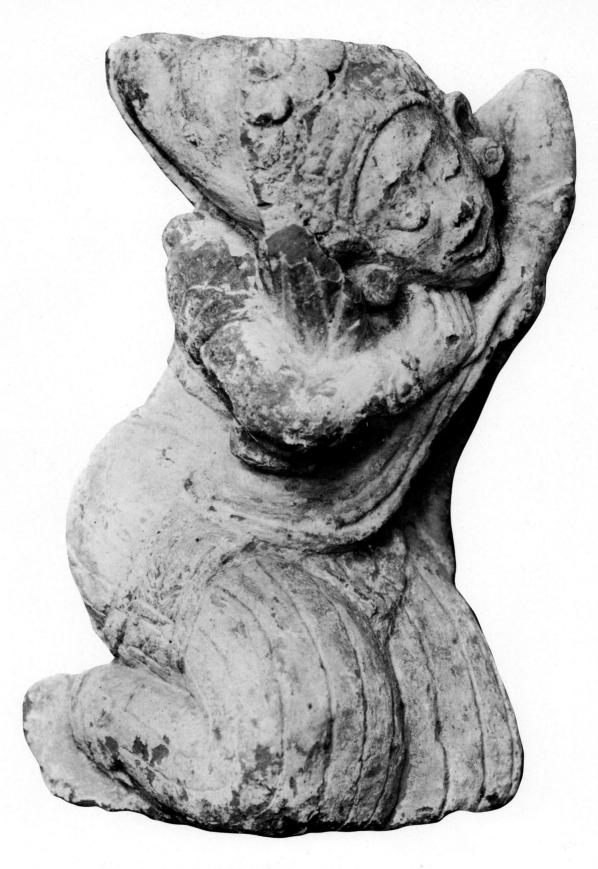

Dancer from Bali. Stone. Indonesia, 15th century A.D. Height 19". (Mayer Collection, New York)

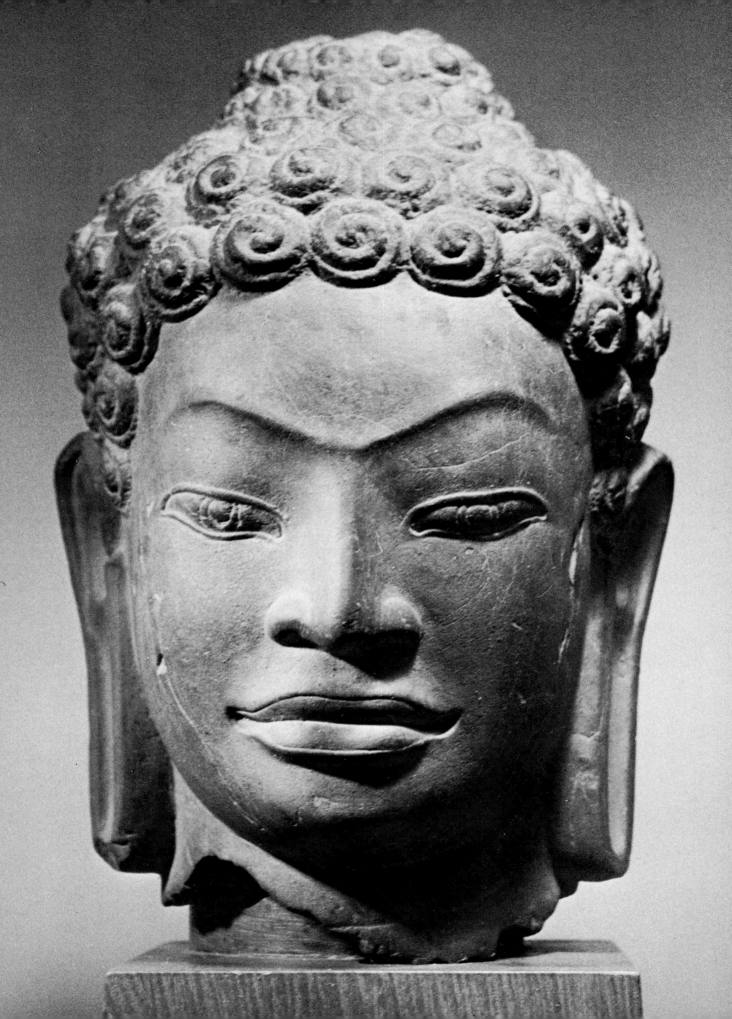

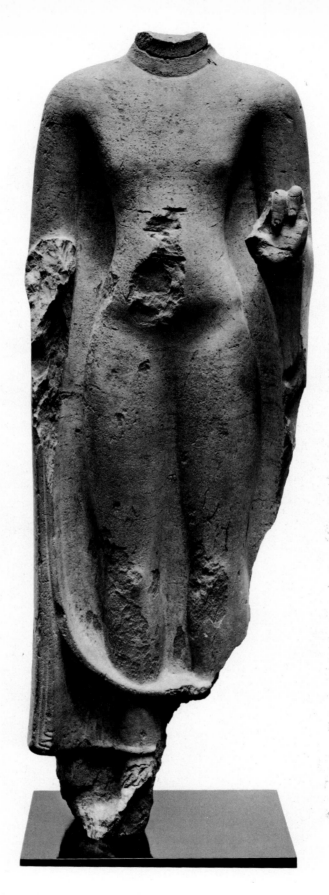

Standing Buddha. Sandstone. Thailand, 8th century A.D.
Height 44". (Goldie Collection, New York)

Opposite: Head of Buddha. Limestone. Thailand, 6th century
A.D. Height 10⅜". (Marks Collection, New York)

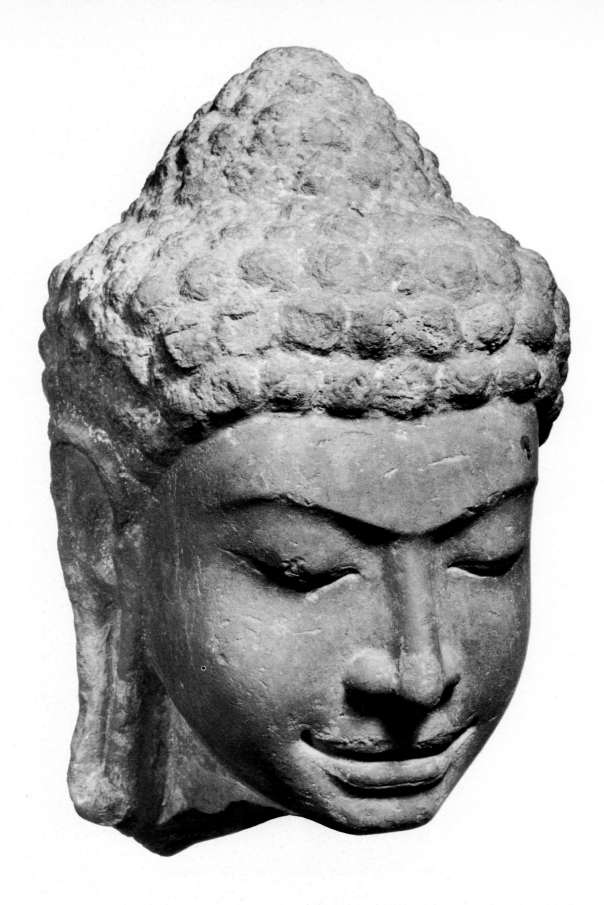

Head of Buddha. Limestone. Thailand, 9th century A.D. Height 9". (Private collection, Switzerland; photo by O. E. Nelson)

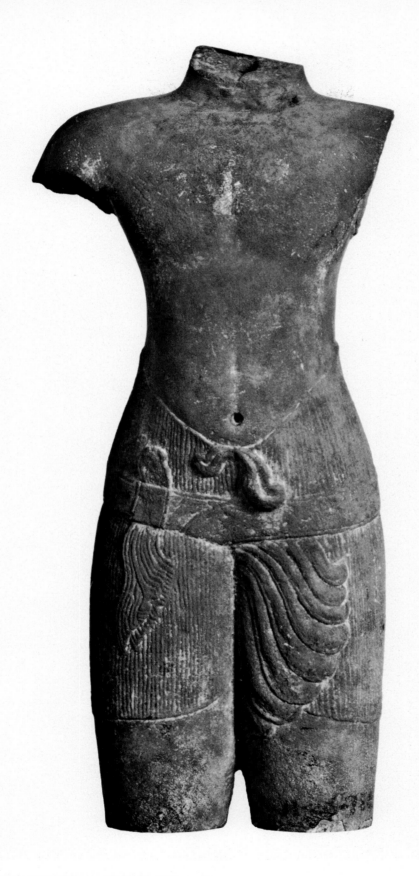

Male torso from Lopburi. Sandstone. Thailand, 12th century A.D. Height 26½". (Museum für Völkerkunde, Munich)

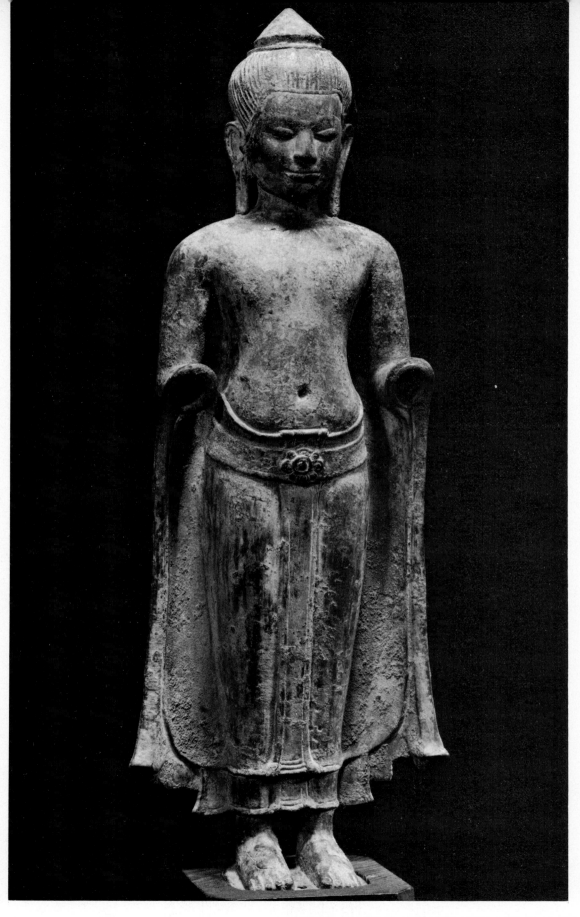

Standing Buddha from Lopburi. Bronze. Thailand, 13th century A.D. Height 17". (Boney Collection, Tokyo)

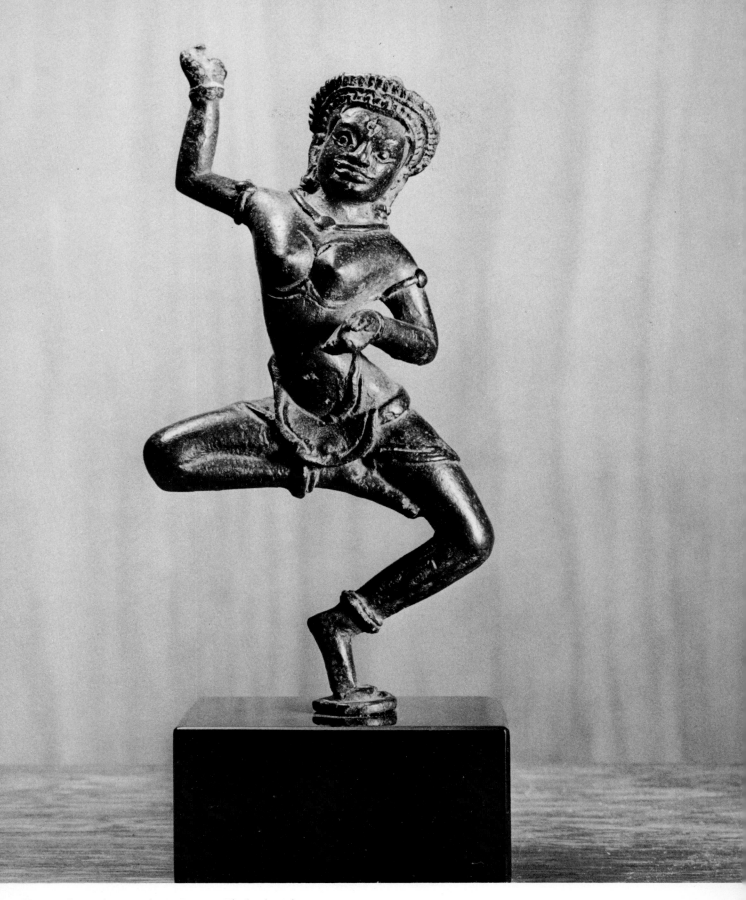

*Dancing figure from Lopburi. Bronze. Thailand, 13th century
A.D. Height 4½". (Private collection, New York)*

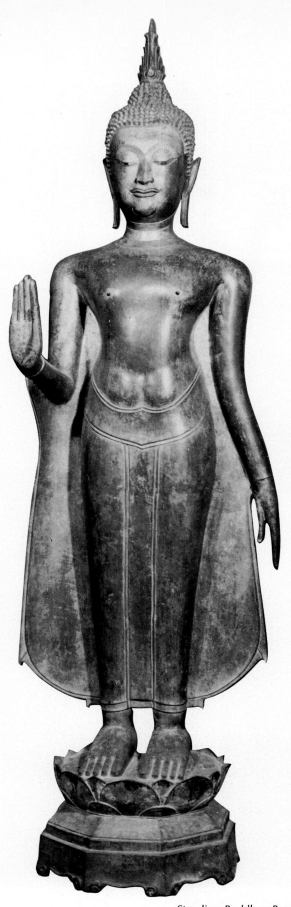

Standing Buddha. Bronze. Thailand, 16th century A.D. Height 68¾". (William Wolff Collection, New York)

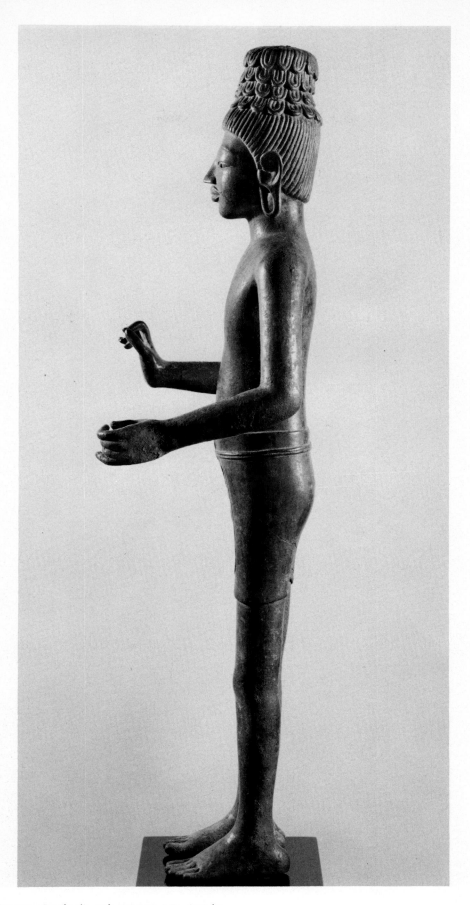

Buddha Maitreya. Bronze. Cambodia, 7th century A.D. Height 22". (Private collection, New York)

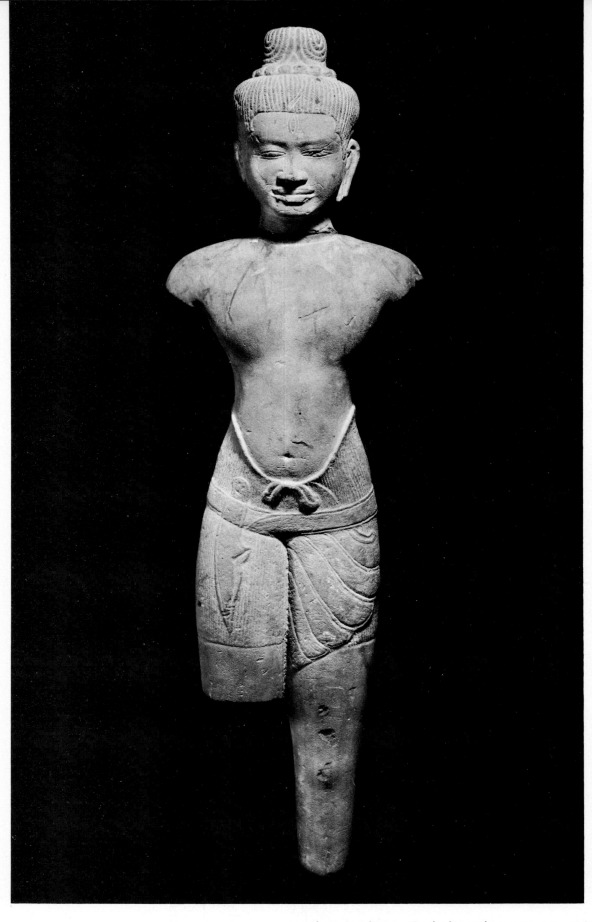

Shiva. Sandstone. Cambodia, 11th century A.D. Height 33".
(Ellsworth Collection, New York)

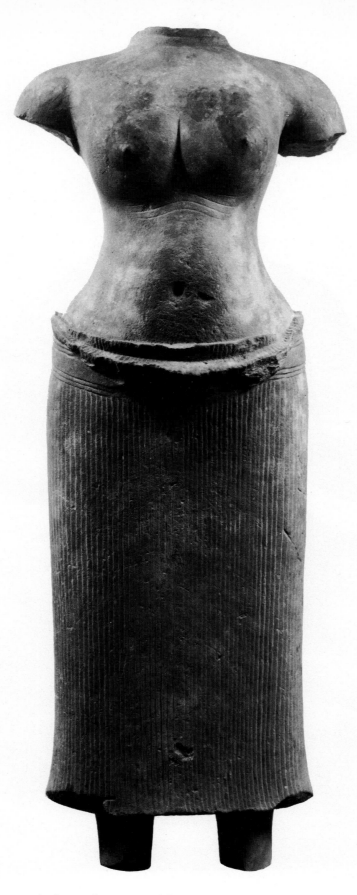

Torso of Uma. Sandstone. Cambodia, 12th century A.D. Height 18". (Eisenberg Collection, New York; photo by Thomas Feist)

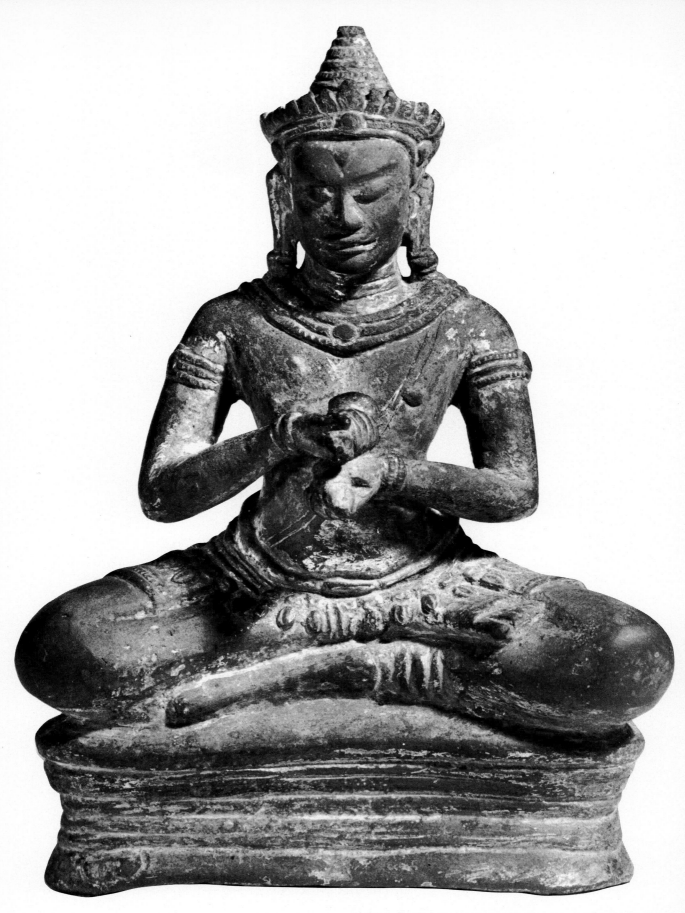

Seated Buddha. Bronze. Cambodia, 12th century A.D. Height 6''. (Private collection, New York)

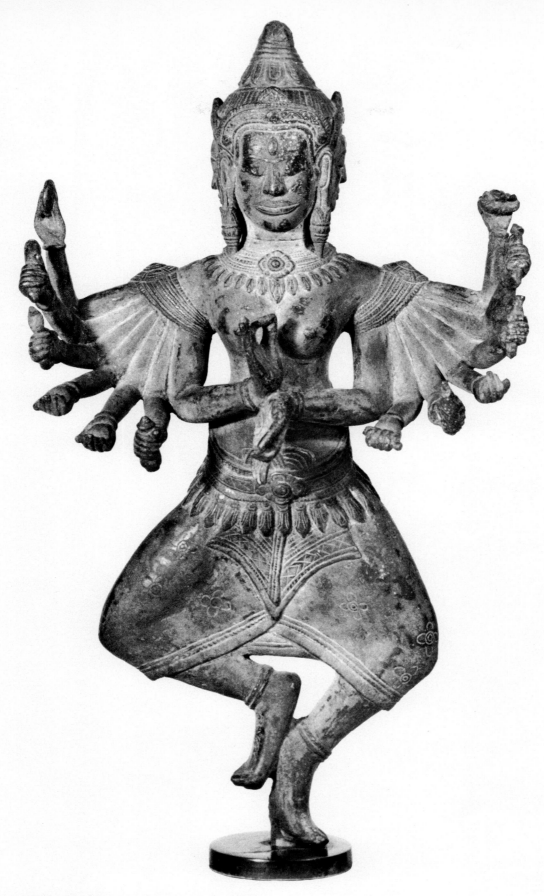

*Dancing deity. Bronze. Cambodia, 12th century A.D. Height
15". (Private collection, New York)*

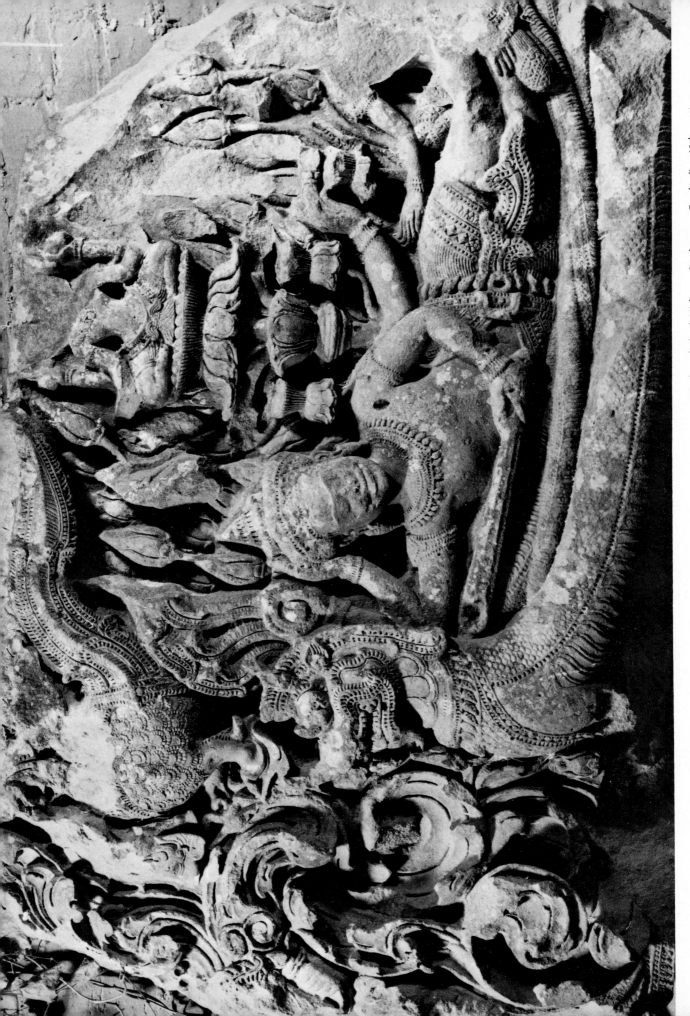

Hindu relief of Vishnu. Sandstone. Cambodia, 12th century A.D. Height 34". (Alsdorf Collection, Winnetka, Ill.; photo by Thomas Feist)

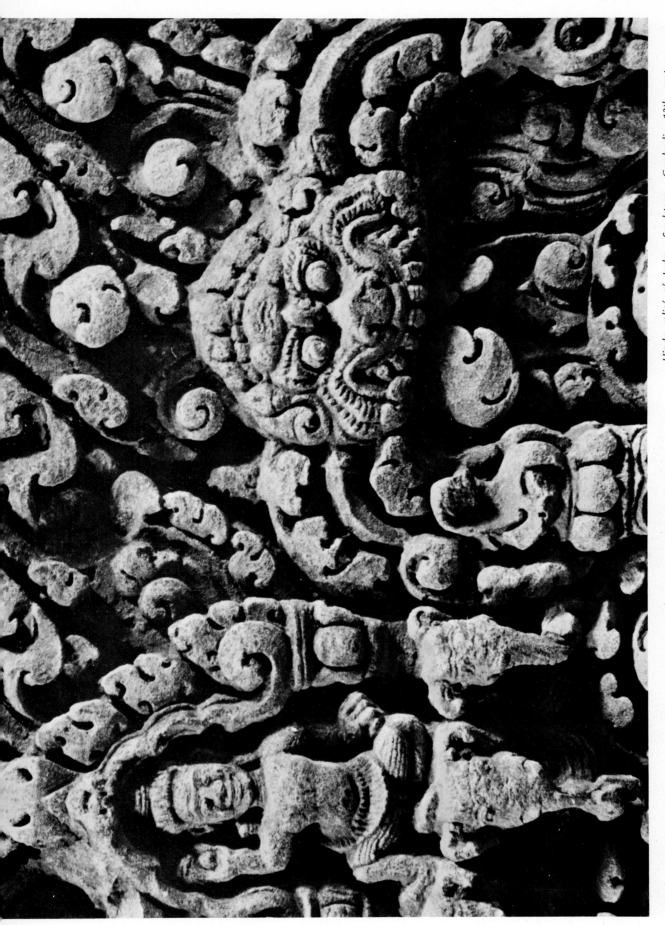

Hindu relief of Indra. Sandstone. Cambodia, 13th century A.D. Height 18½". (Marks Collection, New York)

*Bird. Green nephrite. China, c. 2000 B.C. Height 4⅛".
(William Rockhill Nelson Gallery of Art, Kansas City, Mo.)*

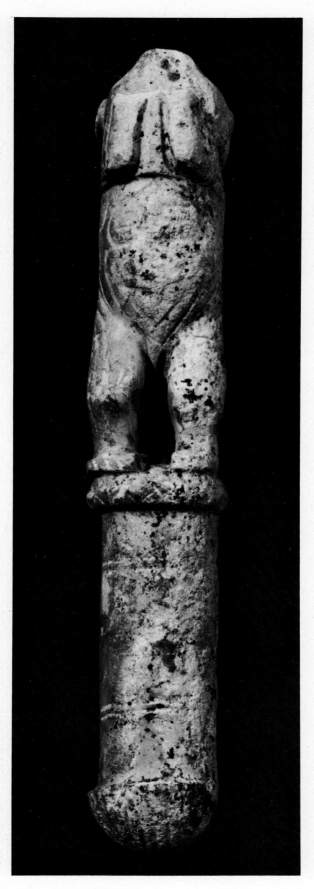

Pestle with monkey handle. Marble. China, 15th century B.C.
Height 6⅝″. (Dr. Singer Collection, Summit, N. J.)

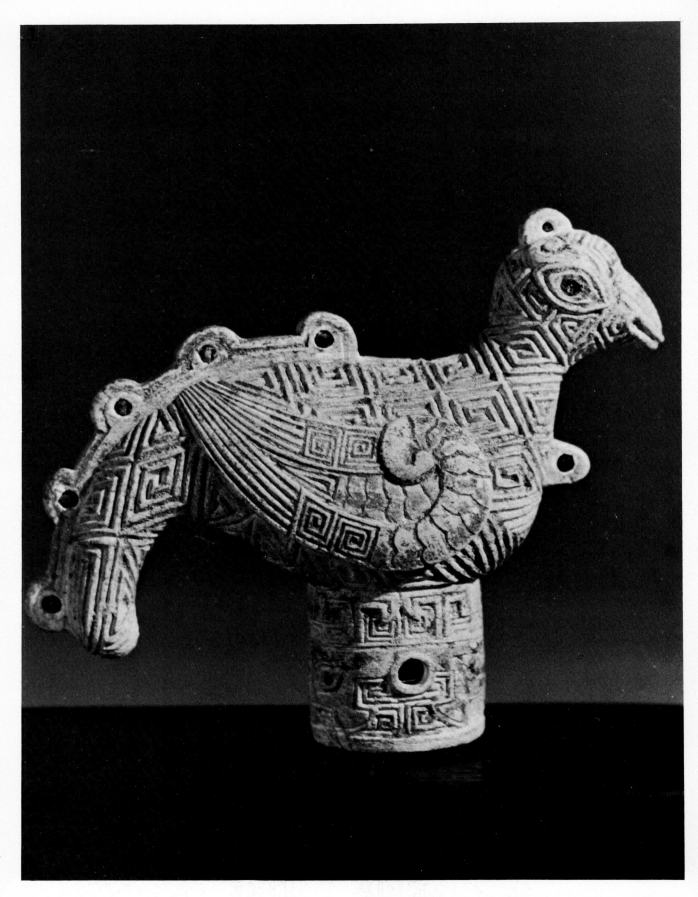

Finial in form of pigeon. White pottery. China, 13th century B.C. Height 3⅛". (Cox Collection, New York)

Ornament in form of bird. Marble. China, 12th century B.C.
Height 4⅝″. (Freer Gallery of Art, Washington, D. C.)

Cover of vessel with bird decoration. Bronze. China, 12th century B. C. Height 8". (Musée Guimet, Paris)

*Stylized animal designs. Bone. China, 12th century B.C.
Length 2¼". (Private collection, New York; photo courtesy
of The Brooklyn Museum)*

Yü-type vessel in owl shape. Bronze. China, 12th century B.C. Height 7½". (Brundage Collection, San Francisco)

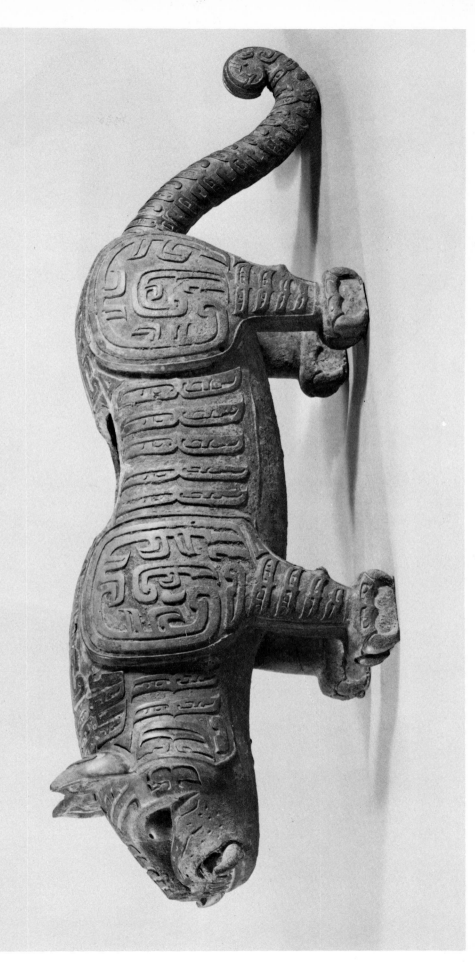

Tiger. Bronze. China, 9th century B.C. Height 9⅞". (Freer Gallery of Art, Washington, D. C.)

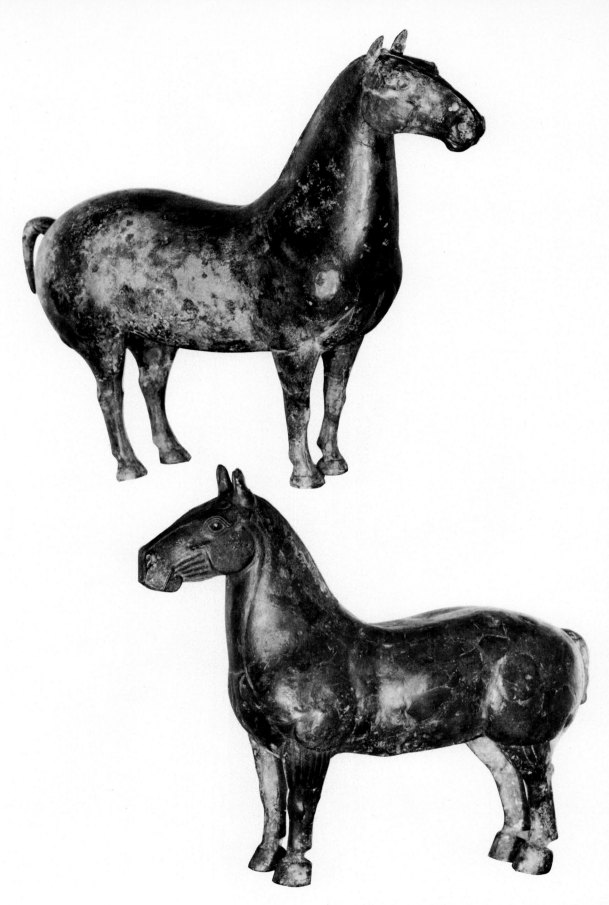

Stallions. Bronze. China, 5th century B.C. Height 8¼".
(William Rockhill Nelson Gallery of Art, Kansas City, Mo.)

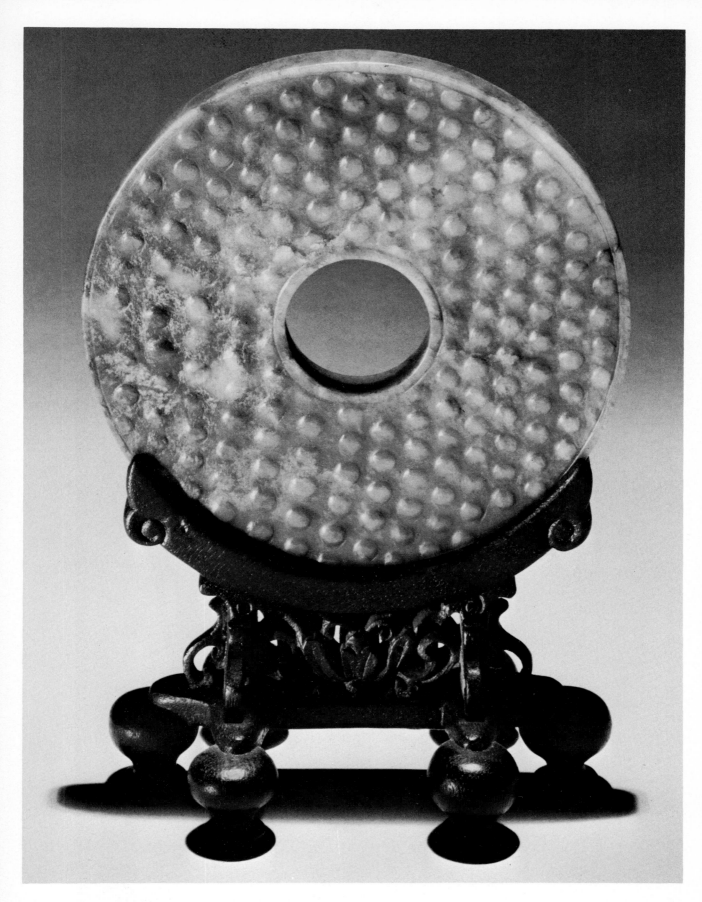

Pi-shaped disk. Jade. China, 5th century B.C. Height 4¾".
(Munsterberg Collection, New Paltz, N. Y.; photo by Raphael
Warshaw)

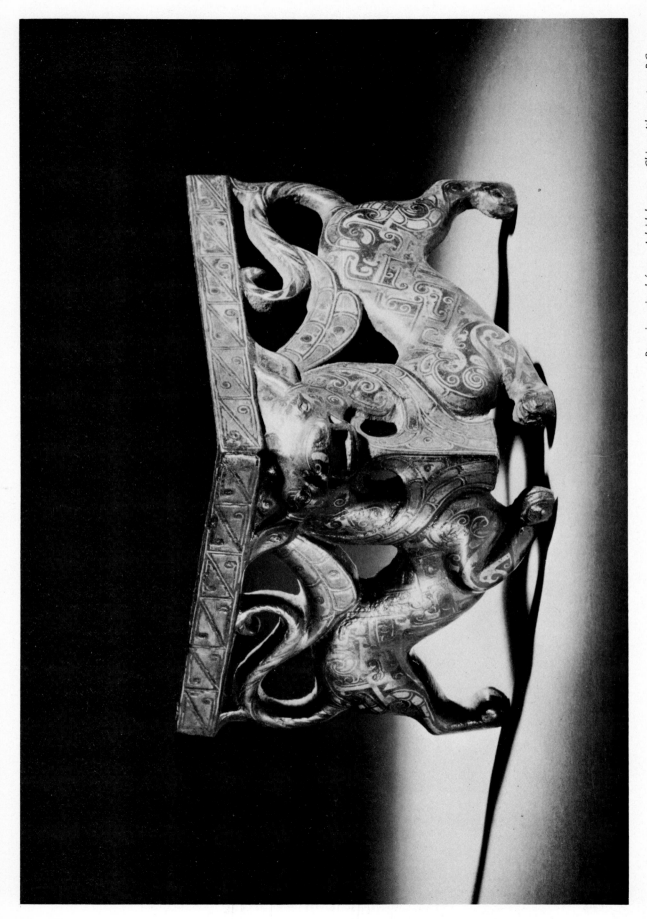

Base in animal form. Inlaid bronze. China, 4th century B.C. Height 3¼". (Sackler Collection, New York; photo by O. E. Nelson)

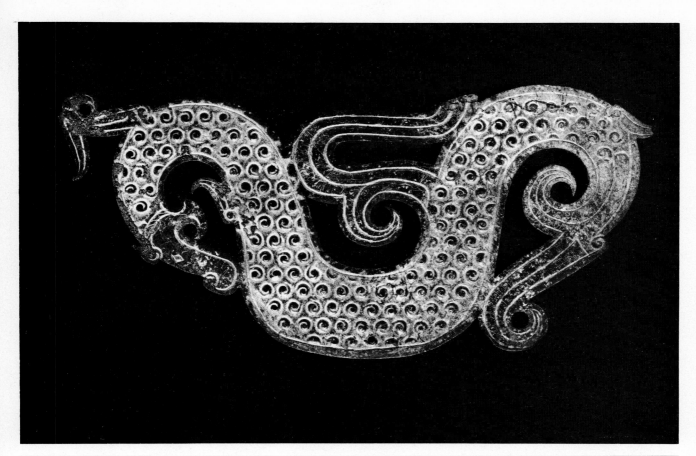

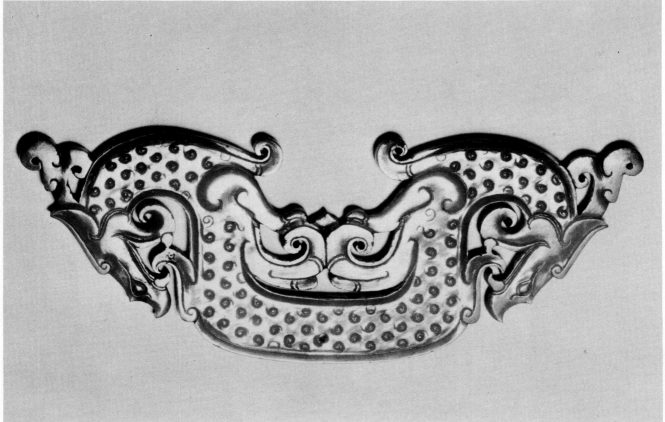

Dragons. Jade. China, 3rd century B.C. Above: Height 2½".
(Musée Guimet, Paris) Below: Length 5". (Fogg Art Museum,
Cambridge, Mass.)

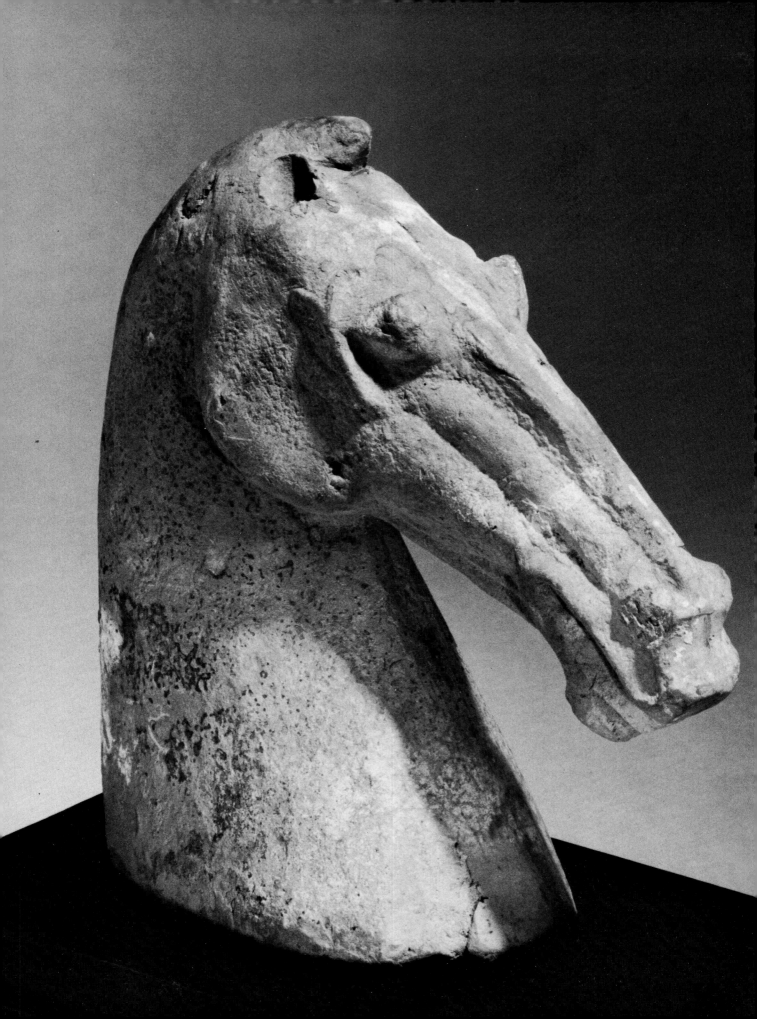

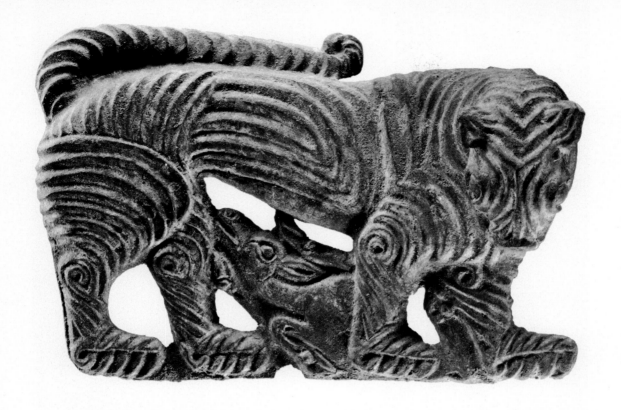

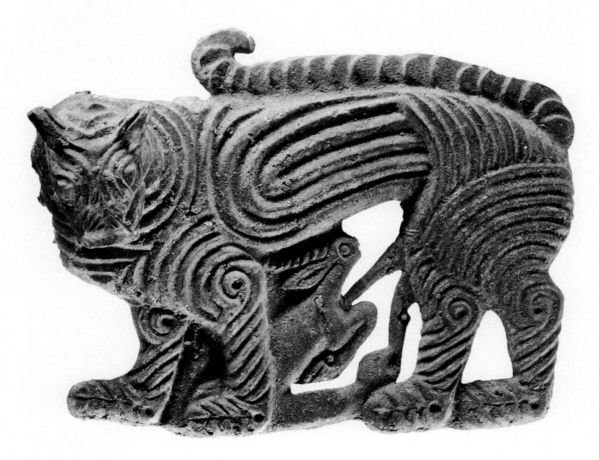

*Animal plaques. Bronze. China, 1st century B.C. Height 4⅝"
and 5½". (William Rockhill Nelson Gallery of Art, Kansas
City, Mo.)*

*Opposite: Horse's head. Terracotta. China, 1st century B.C.
Height 6". (Munsterberg Collection, New Paltz, N. Y.; photo
by Raphael Warshaw)*

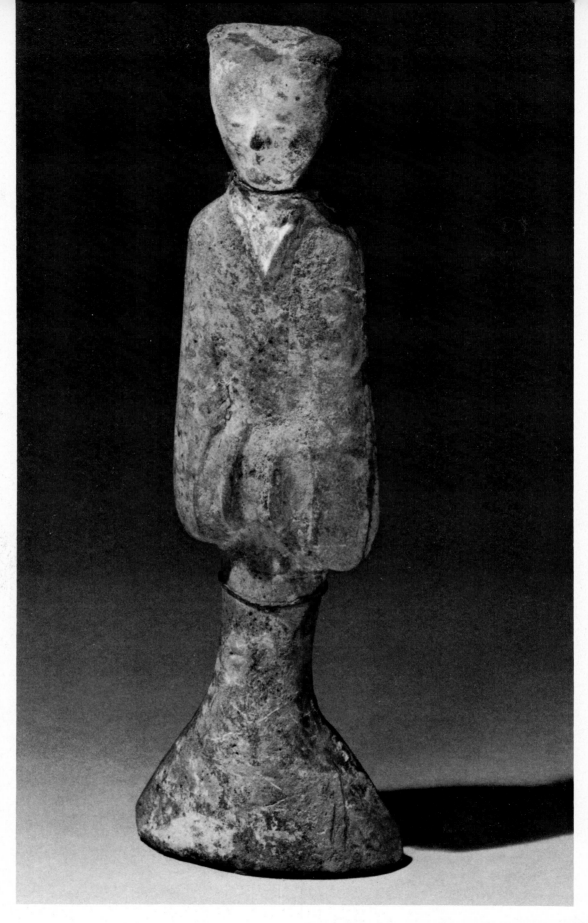

Female figure. Terracotta. China, 2nd century A.D. Height 12⅜".
(Takashige Loan Collection, N. Y. State University College Gallery, New Paltz, N. Y.; photo by Raphael Warshaw)

Chimera. Stone. China, 4th century A.D. Height 51½". (William Rockhill Nelson Gallery of Art, Kansas City, Mo.)

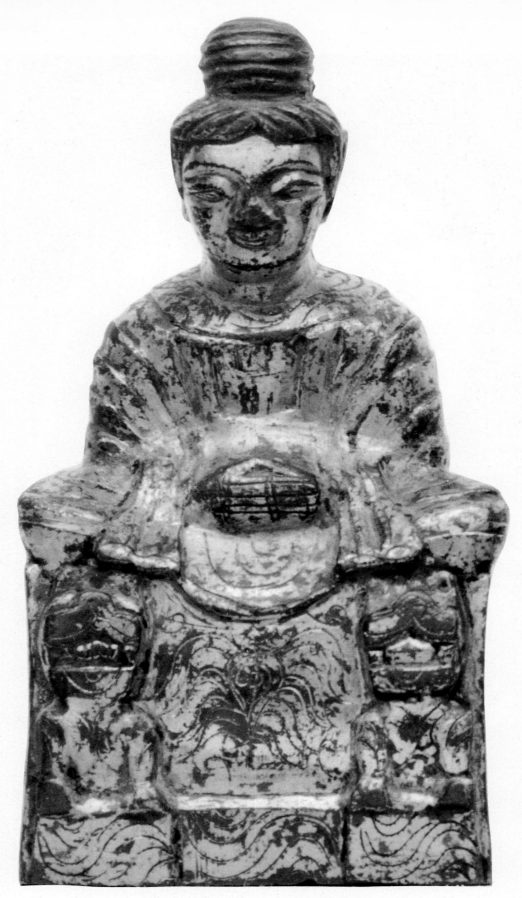

Buddha Sakyamuni. Gilt bronze. China, 4th century A.D. Height 3½". (Mills College, Oakland, Calif.)

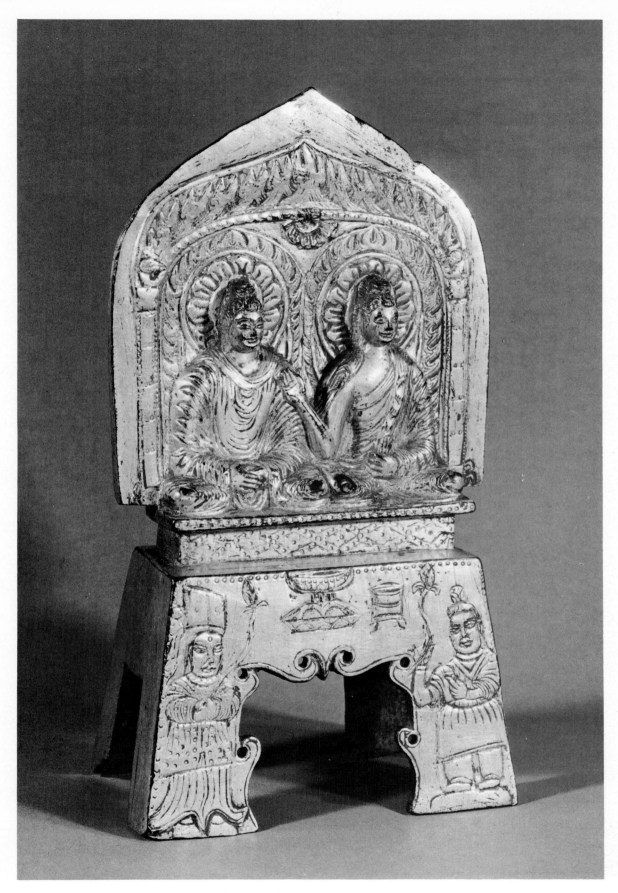

*Sakyamuni with the Buddha of the Past. Gilt bronze. China,
5th century A.D. Height 8" (Nezu Institute of Fine Arts, Tokyo)*

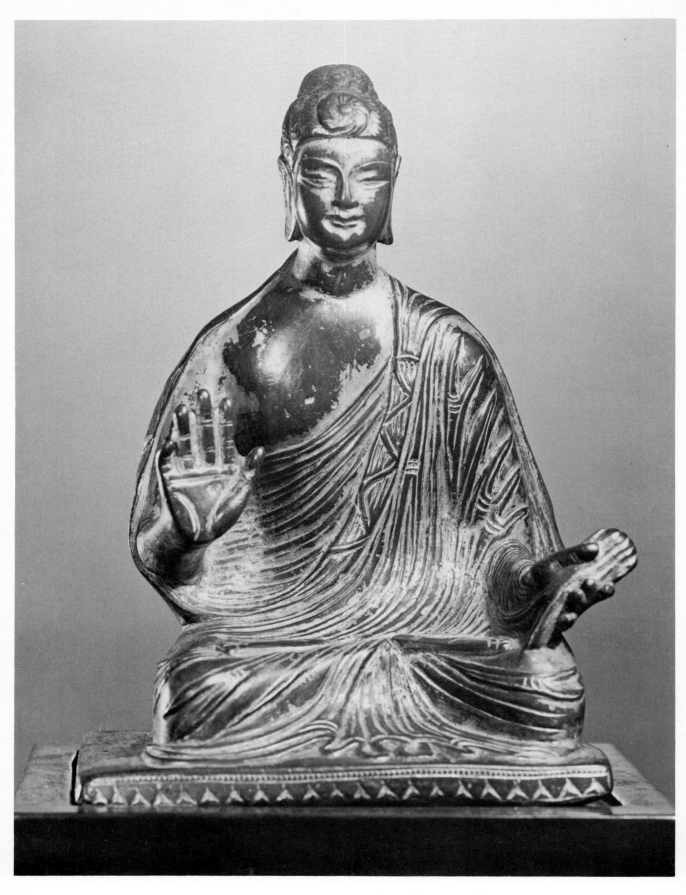

Buddha. Gilt bronze. China, 5th century A.D. Height 10¼".
(William Rockhill Nelson Gallery of Art, Kansas City, Mo.)

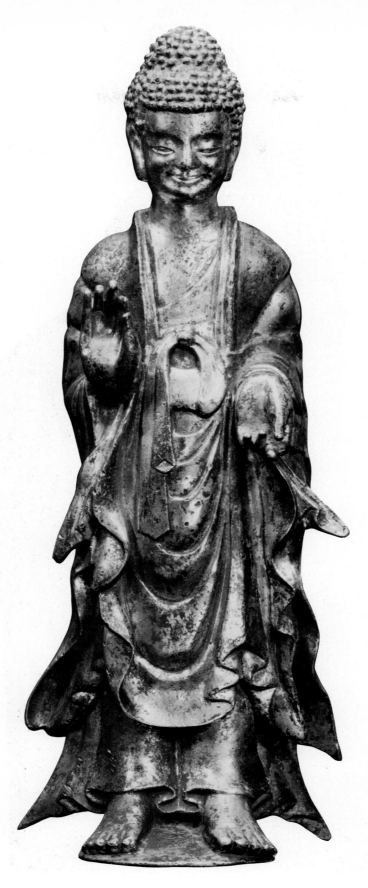

Buddha Maitreya. Gilt bronze. China, 6th century A.D. Height 9½". (Boney Collection, Tokyo)

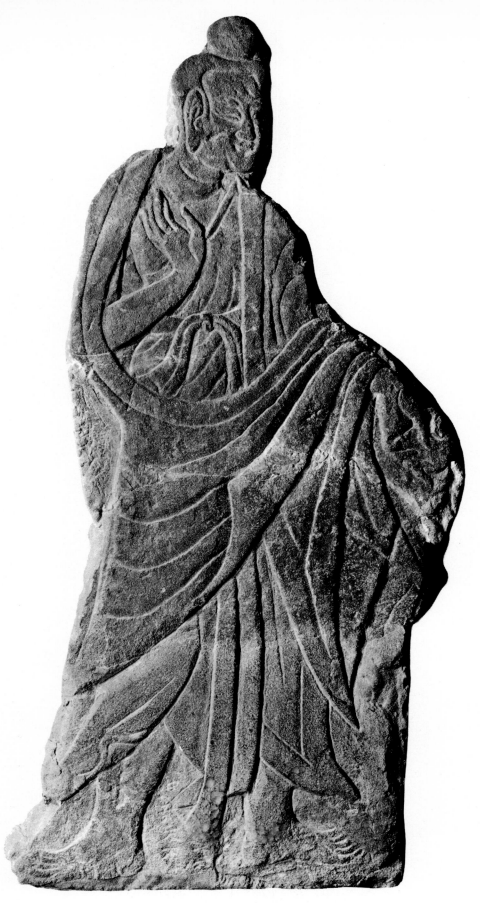

Buddhist figure from T'ien Lung Shan. Sandstone. China, 6th century A.D. Height 47½''. (William Rockhill Nelson Gallery of Art, Kansas City, Mo.)

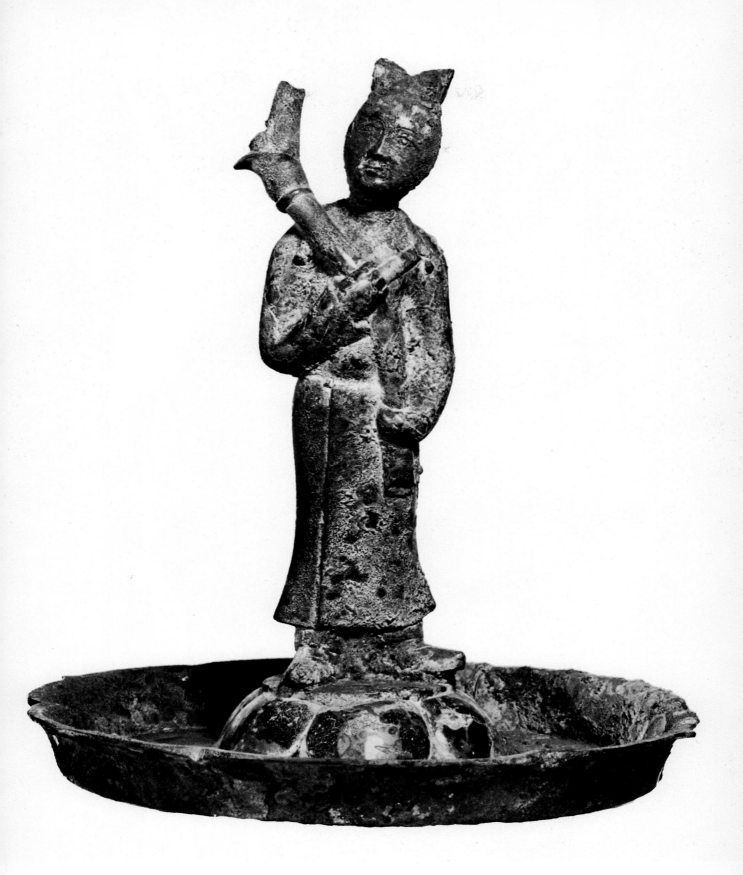

Buddhist figure. Bronze. China, 6th century A.D. Height 9 9/16". (Freer Gallery of Art, Washington, D. C.)

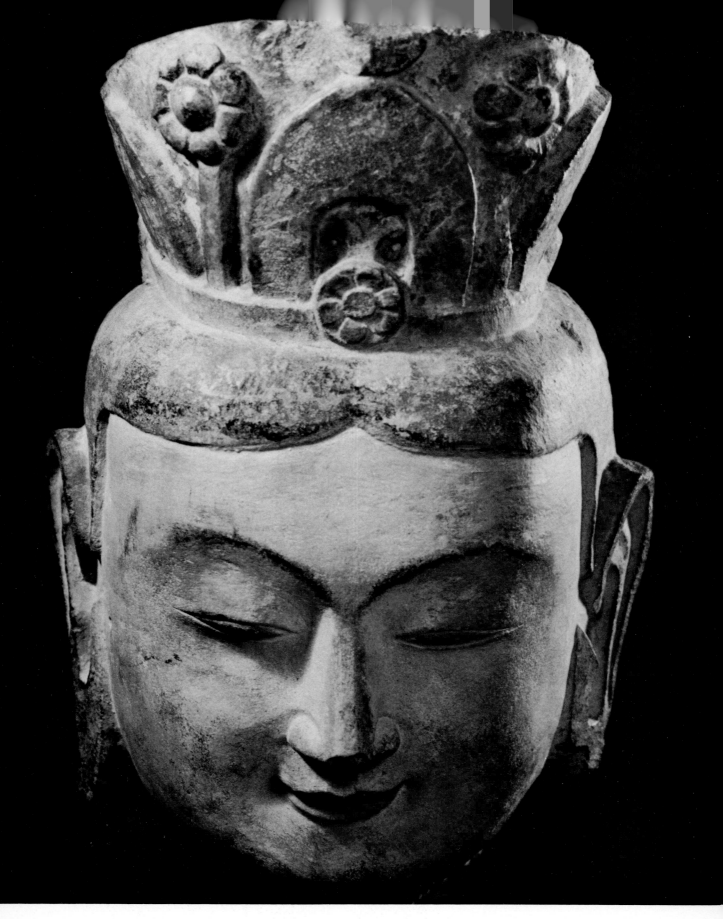

Head of a Bodhisattva from Lung-men. Limestone. China, 6th century A.D. Height 14½". (Brooklyn Museum)

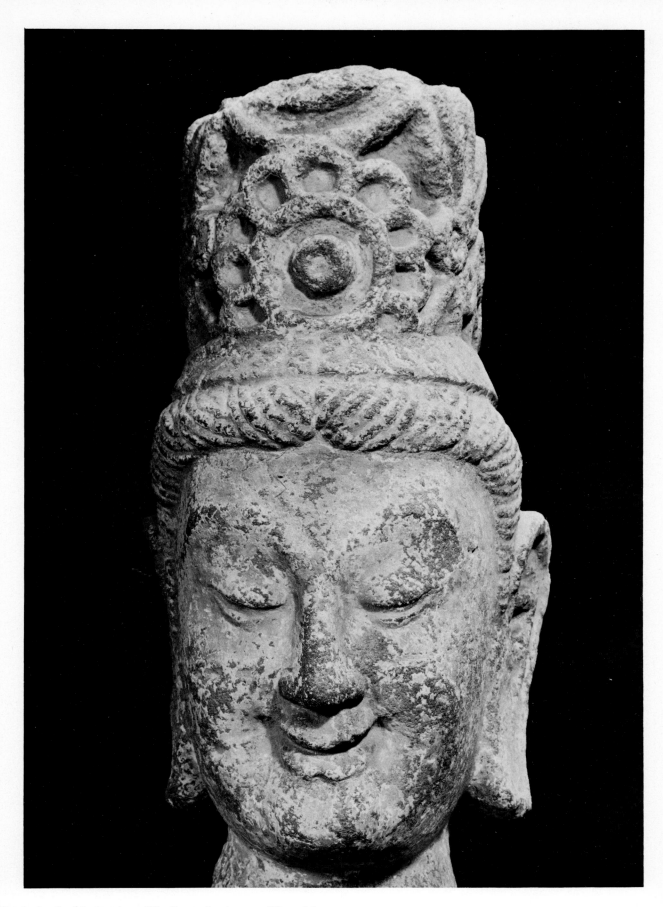

*Head of a Bodhisattva from Yün Kang. Sandstone. China, 6th
century A.D. Height 18". (Morse Collection, New York)*

China 79

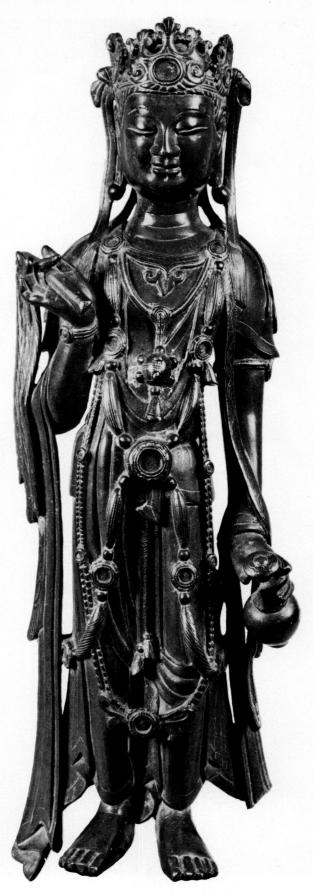

Kuan Yin. Gilt bronze. China, c. 600 A.D. Height 12½″. (Caro Collection, New York)

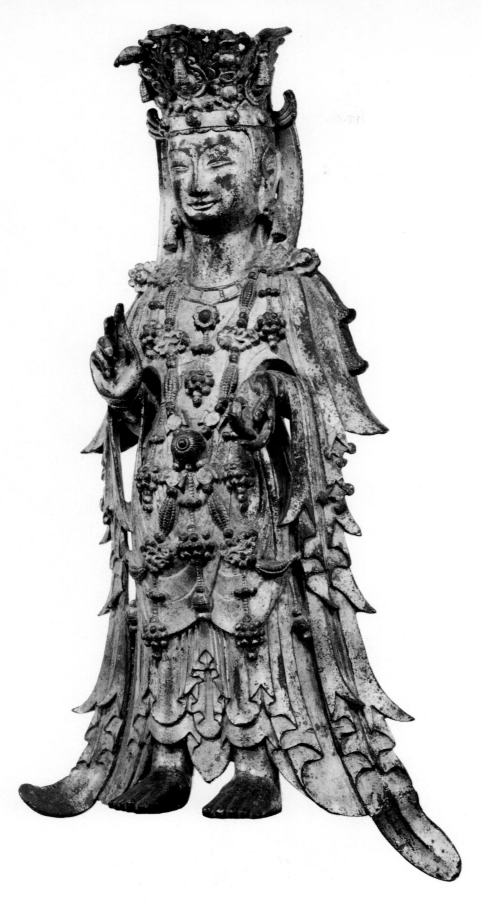

Jeweled Bodhisattva. Gilt bronze. China, 6th century A.D.
Height 16½″. (Tokyo University of Arts)

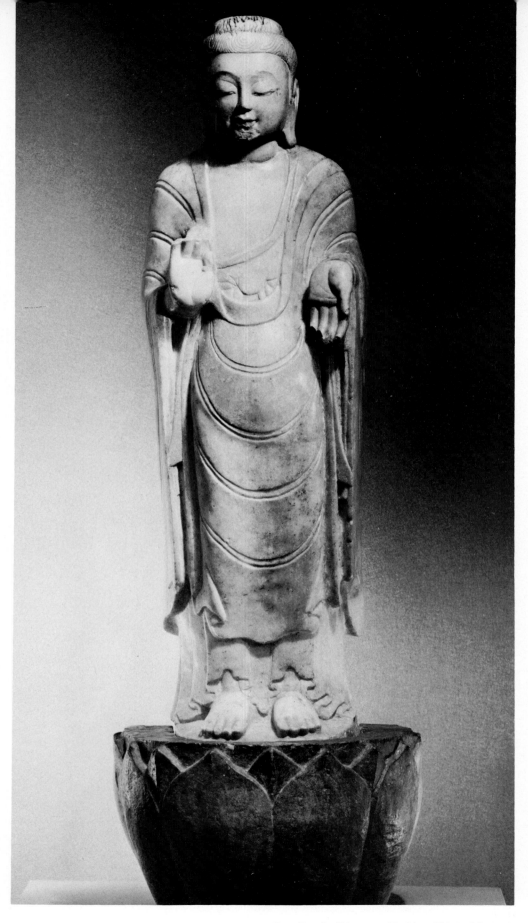

Standing Bodhisattva. Marble. China, 6th century A.D. Height 44¾". (Sackler Collection, New York; photo by O. E. Nelson)

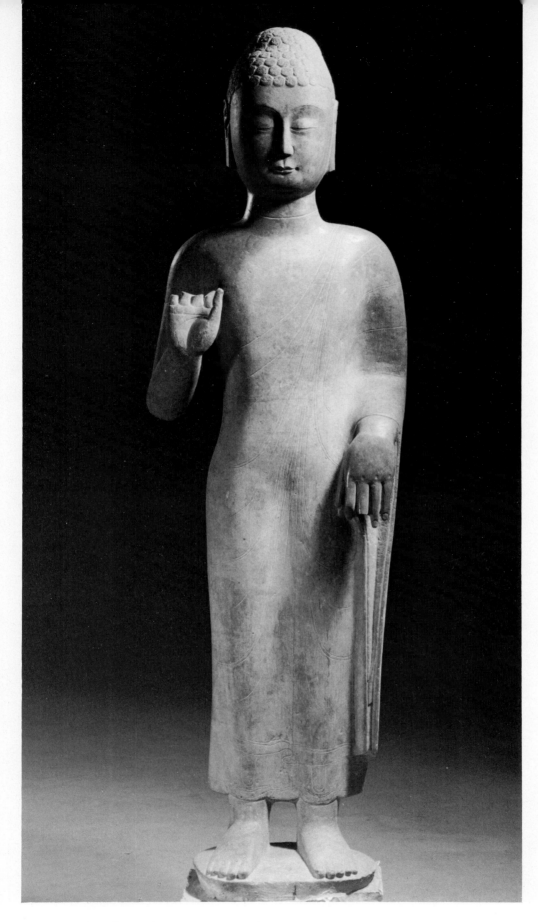

*Standing Bodhisattva. Marble. China, 6th century A.D. Height
67". (Sackler Collection, New York; photo by O. E. Nelson)*

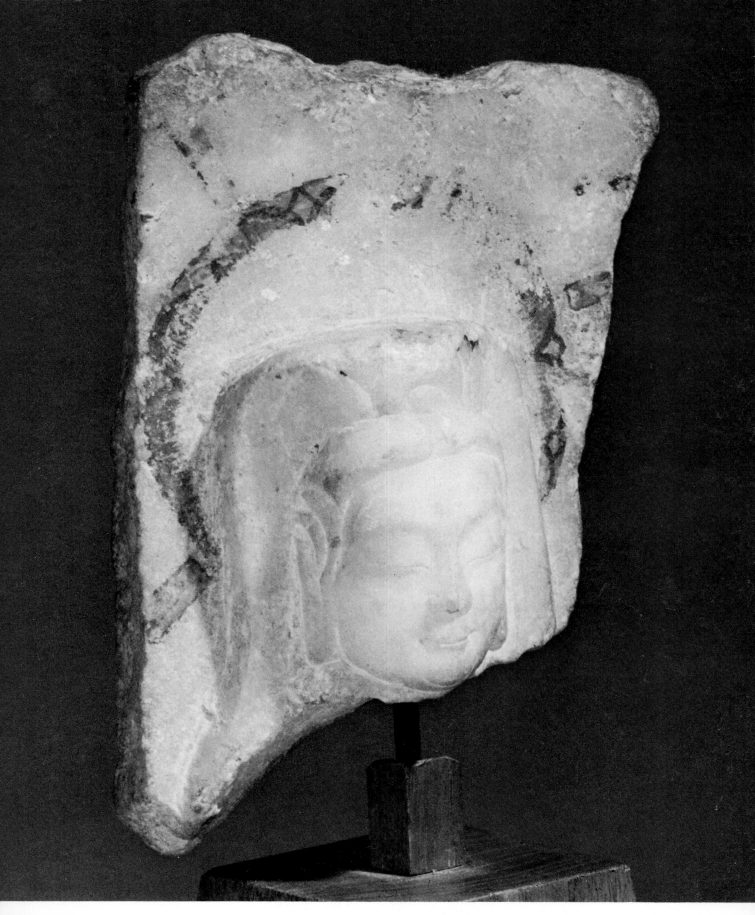

Head of a Bodhisattva. Marble. China, 6th century A.D. Height 5″. (Munsterberg Collection, New Paltz, N. Y.; photo by Raphael Warshaw)

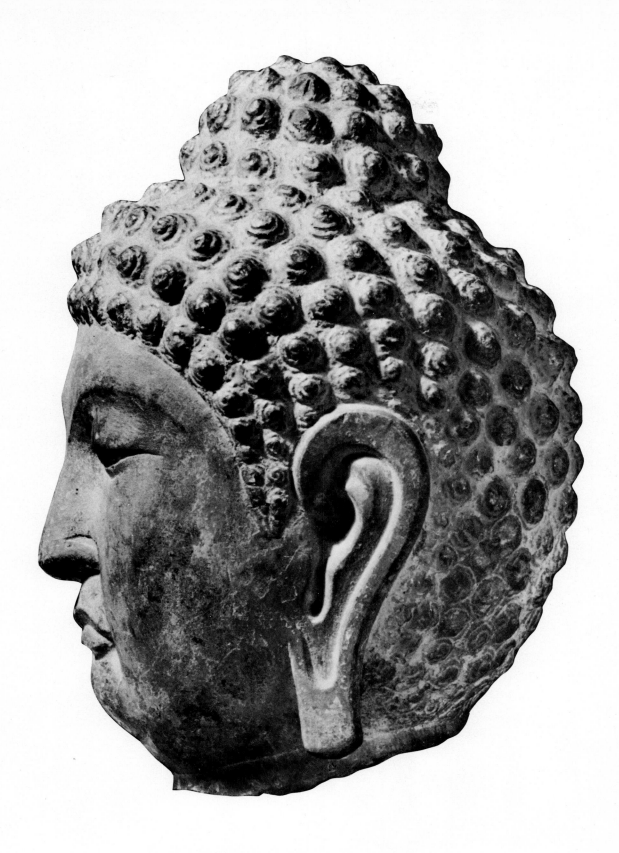

Head of Buddha. Limestone. China, 7th century A.D. Height 10½". (Morse Collection, New York)

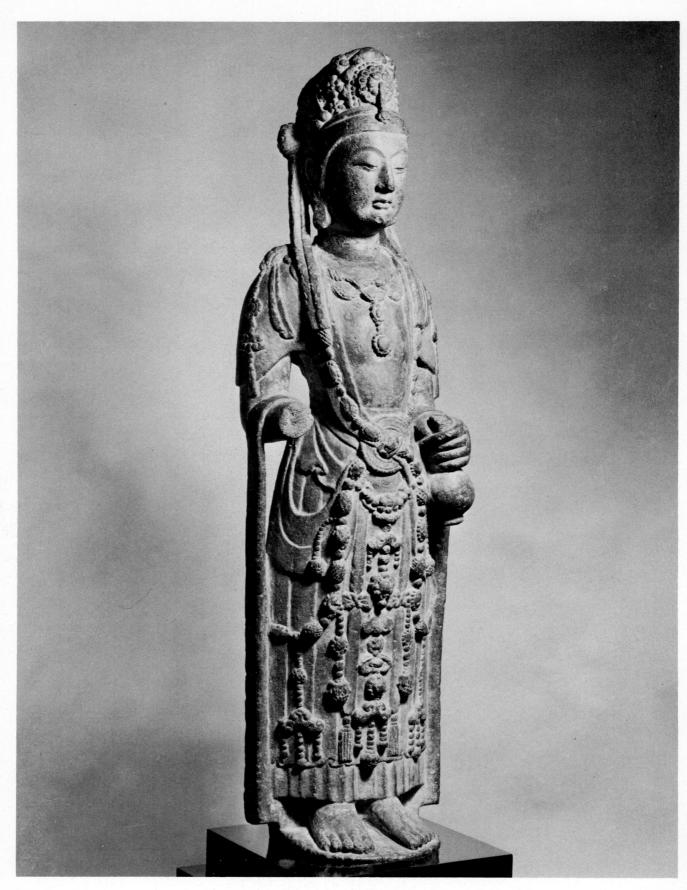

Kuan Yin. Limestone. China, 7th century A.D. Height 40".
(Morse Collection, New York; photo by O. E. Nelson)
Opposite: Head of a Bodhisattva. Limestone. China, 7th century
A.D. Height 20". (Sackler Collection, New York; photo by O. E.
Nelson)

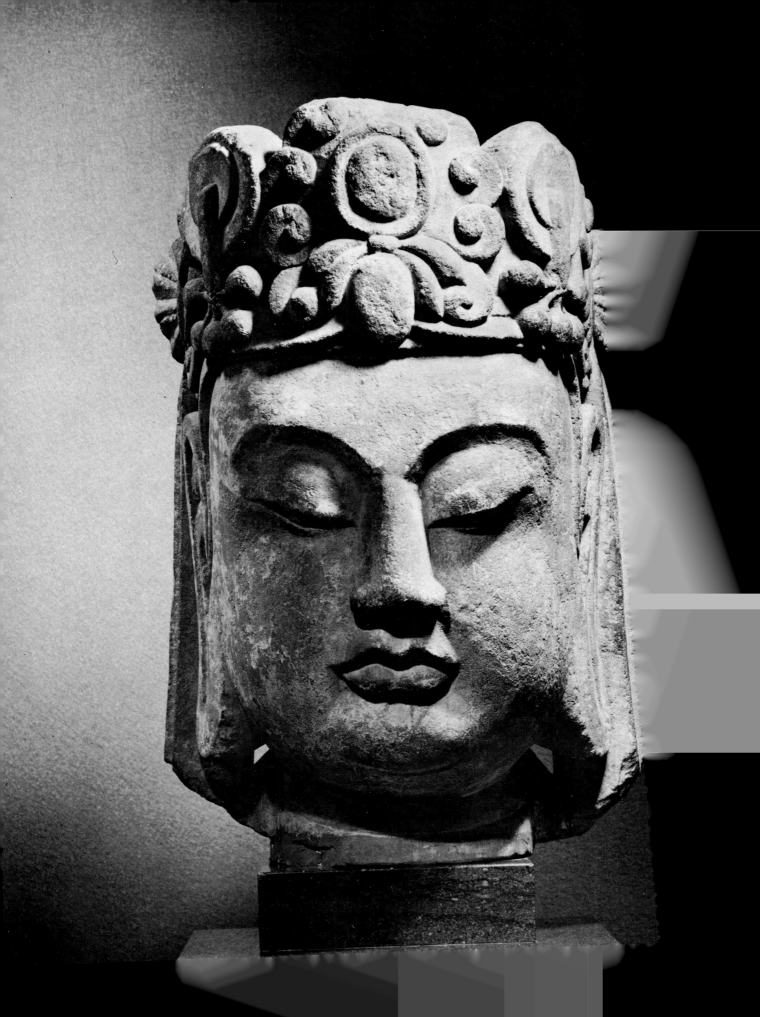

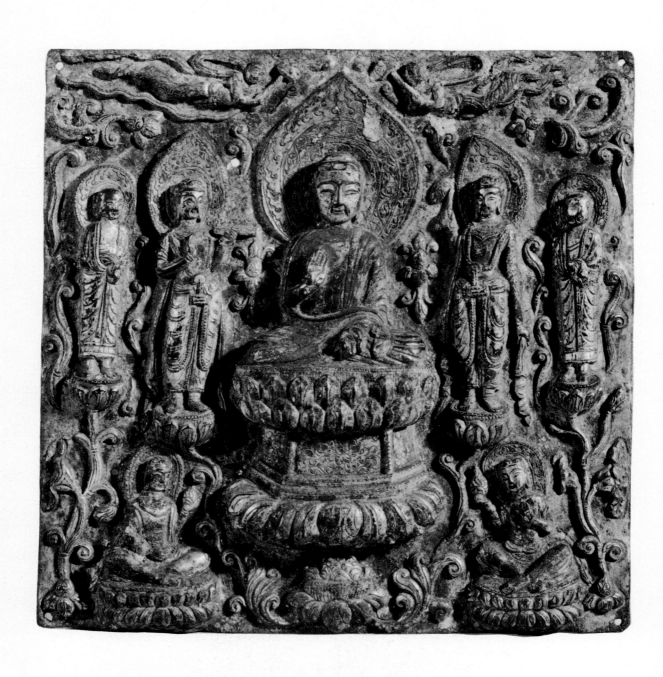

Buddhist plaque. Gilt bronze. China, 7th century A.D. Height 5¼". (Hosokawa Collection, Tokyo)

Fragment from Buddhist cave sculpture at Lung-men. Stone. China, 7th century A.D. Height 14½". (Morse Collection, New York)

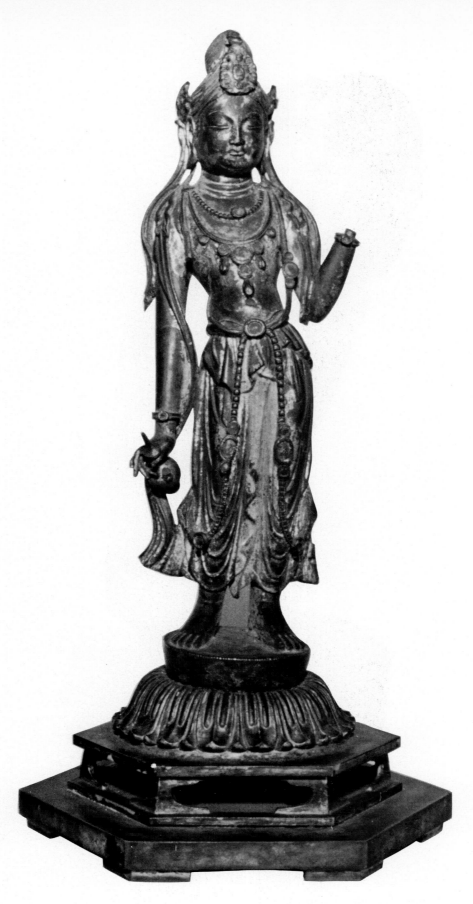

Kuan Yin. Gilt bronze. China, 7th century A.D. Height 13½".
(Private collection, Japan)

90 China

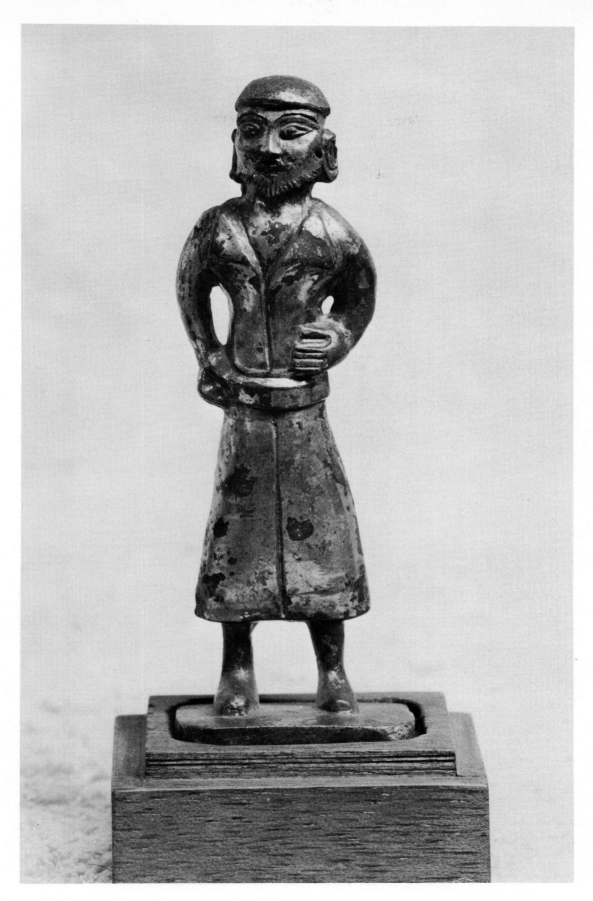

Male figure. Gilt bronze. China, 7th century A.D. Height 3½". (Hart Collection, New York)

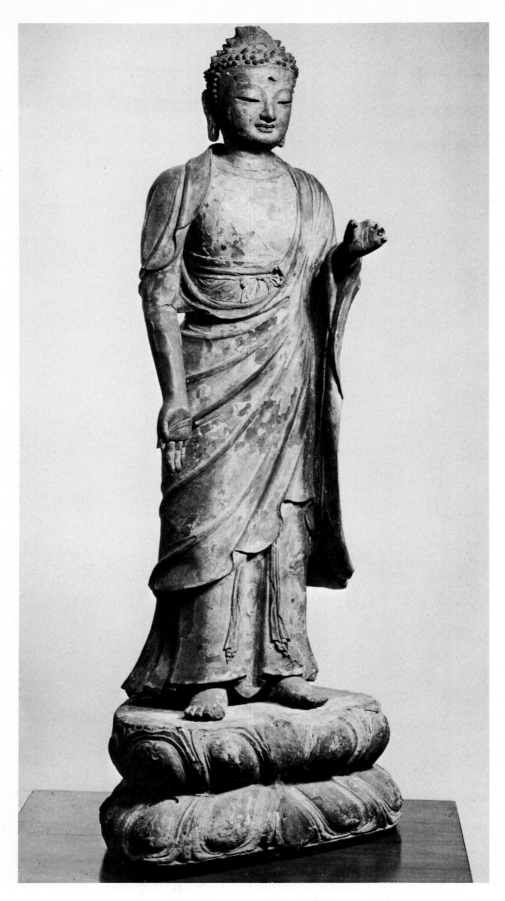

Standing Buddha. Lacquer. China, 7th century A.D. Height 51" with stand. (Sackler Collection, New York; photo by O. E. Nelson)

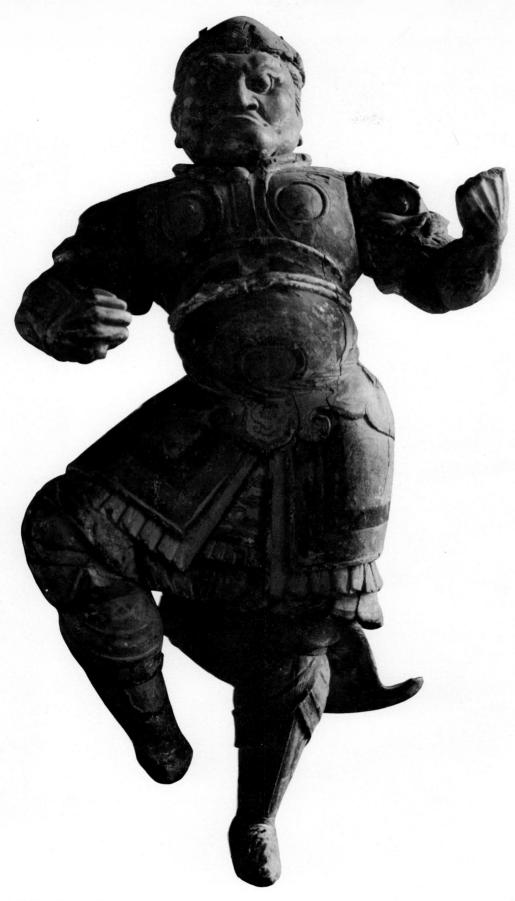

*Guardian figure. Painted clay. China, 7th century A.D. Height
25". (Musée Guimet, Paris)*

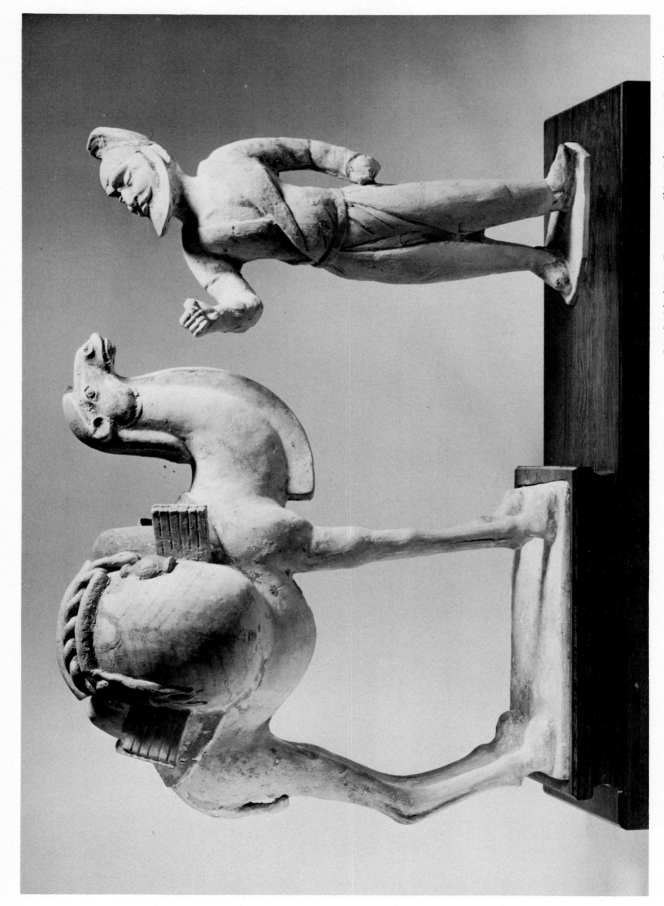

Camel with driver. Terracotta. China, 7th century A.D. Height 14". (Morse Collection, New York; photo by O. E. Nelson)

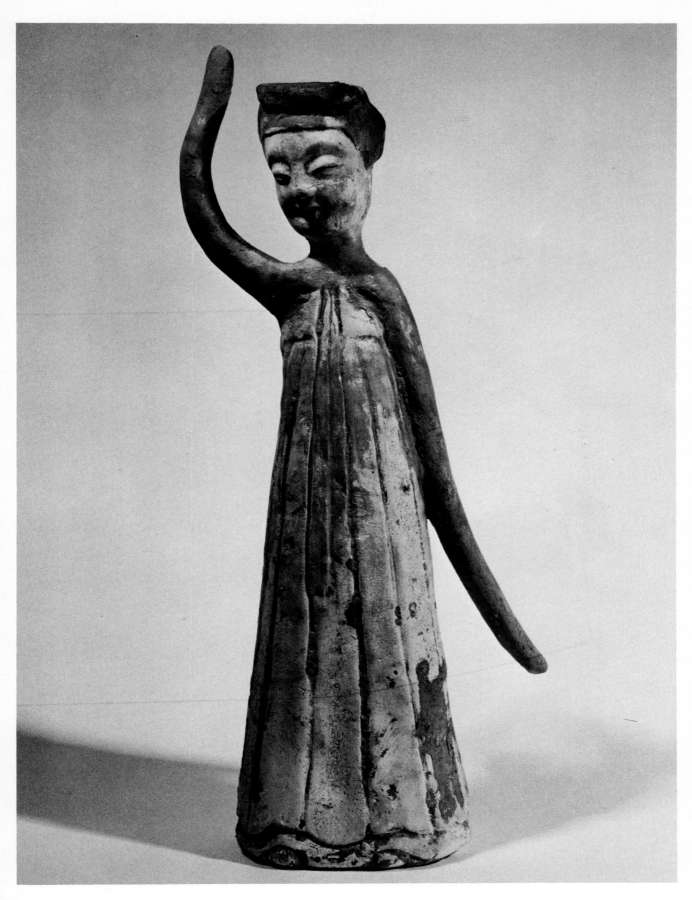

Dancer. Terracotta. China, 7th century A.D. Height 8½".
(Chait Collection, New York)

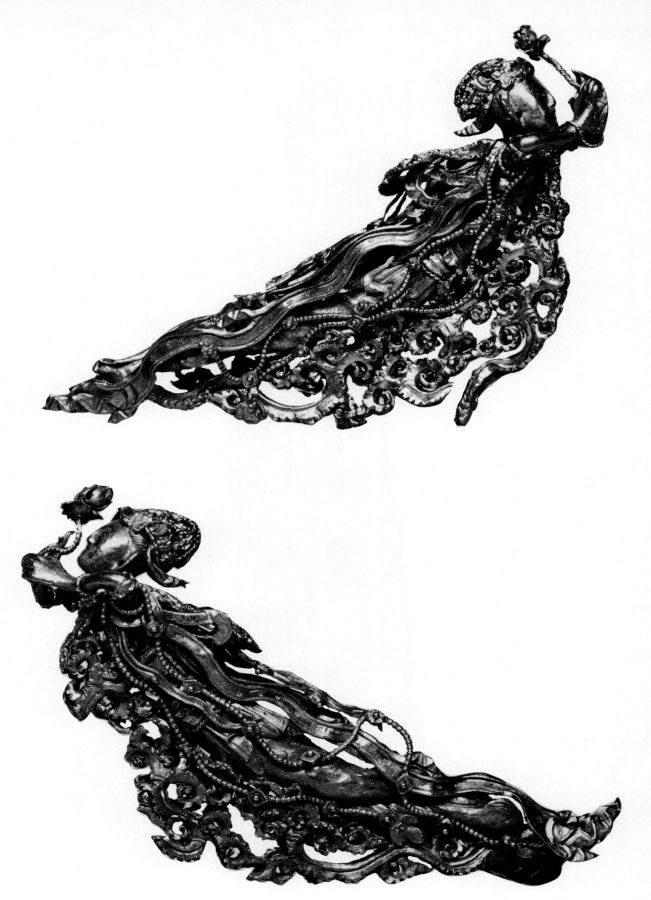

Flying apsaras. Gold. China, 8th century A.D. Height 1½".
(Freer Gallery of Art, Washington, D. C.)

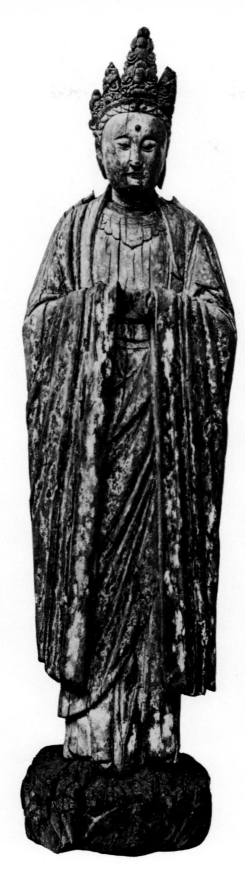

*Kuan Yin. Wood. China, 10th century A.D. Height 76". (British
Museum, London)*

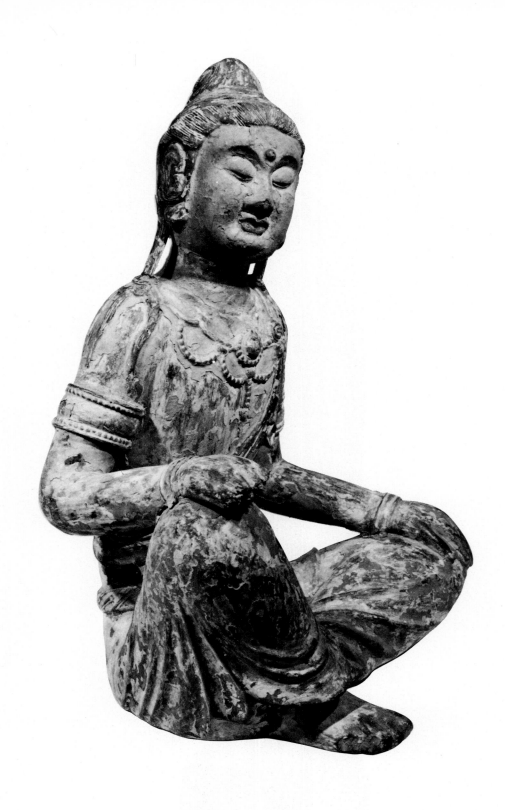

Seated Kuan Yin. Polychromed lacquer. China, 11th century A.D. Height 18¾". (Chait Collection, New York)

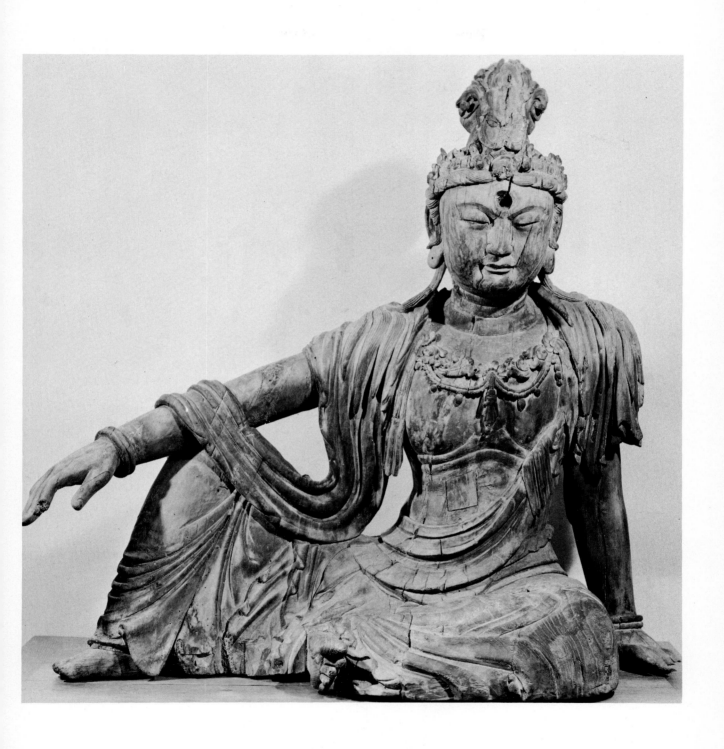

Seated Kuan Yin. Wood. China, 12th century A.D. Height 44".
(Morse Collection, New York)

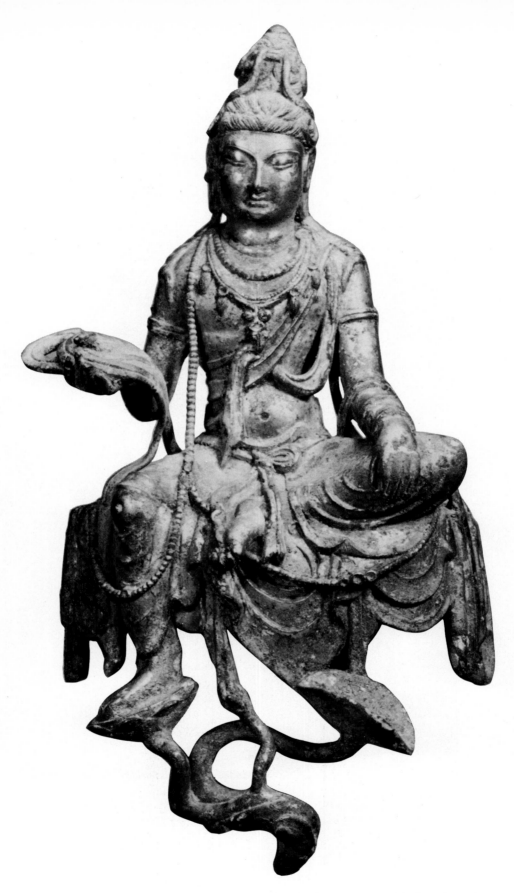

Seated Kuan Yin. Gilt bronze. China, 12th century A.D. Height 8". (Atami Art Museum)

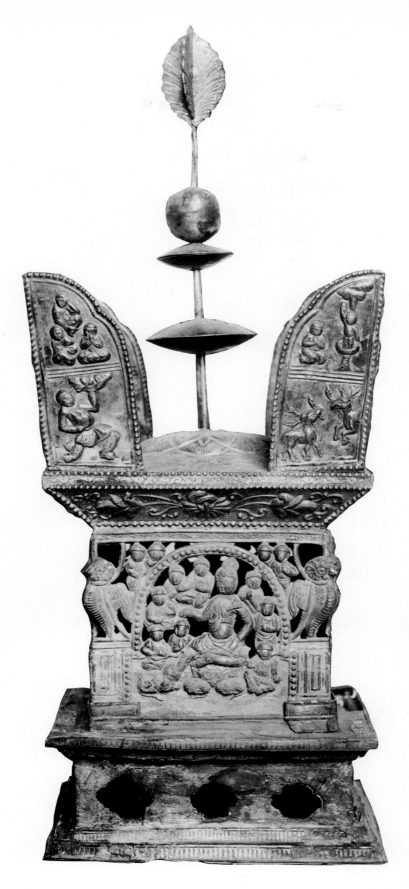

Buddhist reliquary. Silver. China, 12th century A.D. (Musée Guimet, Paris)

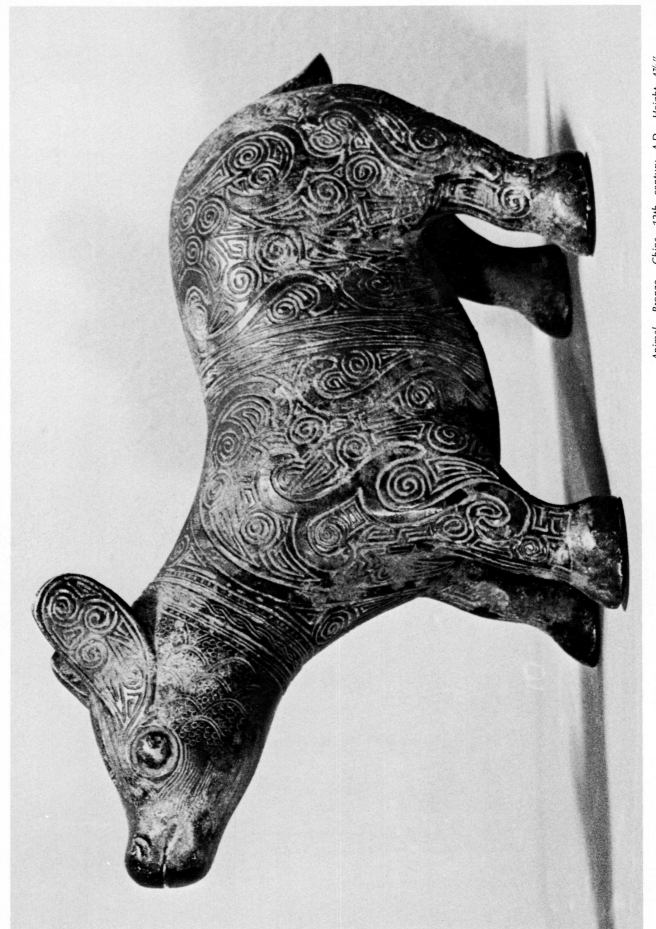

Animal. Bronze. China, 12th century A.D. Height 4⅞".
(Haldeman Collection, Brookline, Mass.)

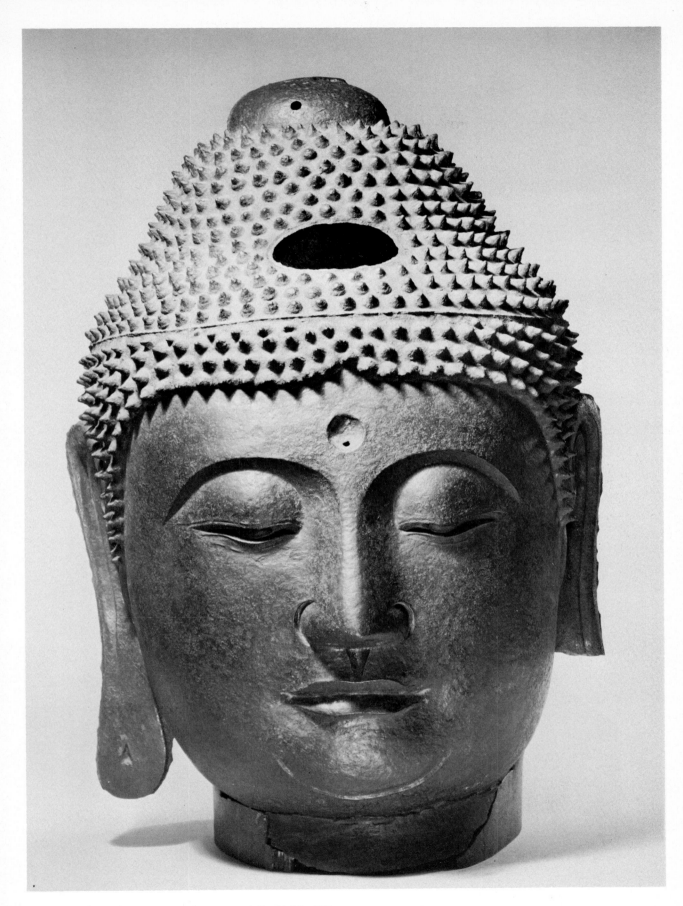

Head of Buddha. Iron. China, 13th century A.D. Height 33".
(Sackler Collection, New York; photo by O. E. Nelson)

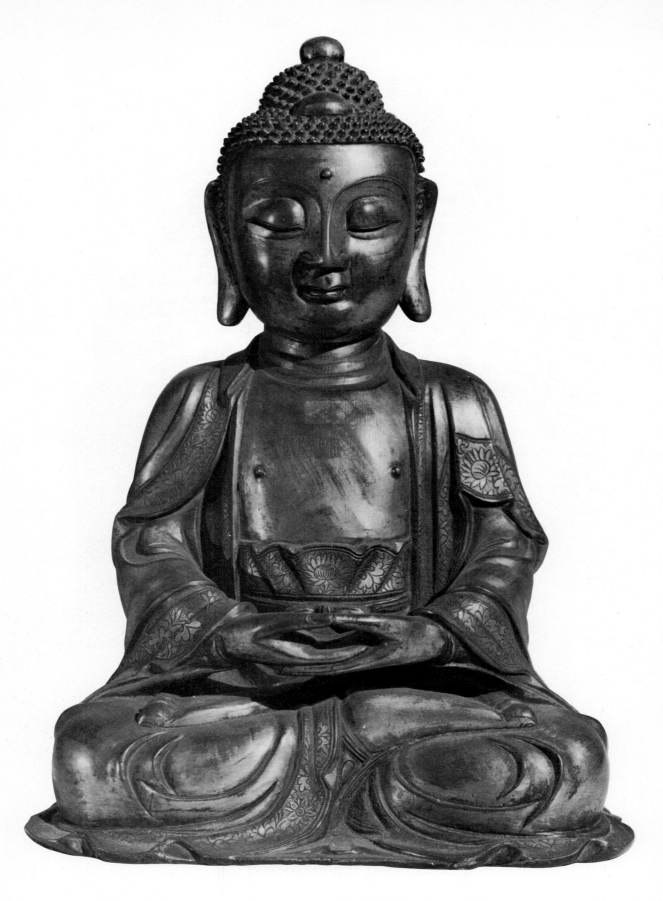

Seated Buddha. Bronze. 16th century A. D. Height 14". (Cox Collection, New York)

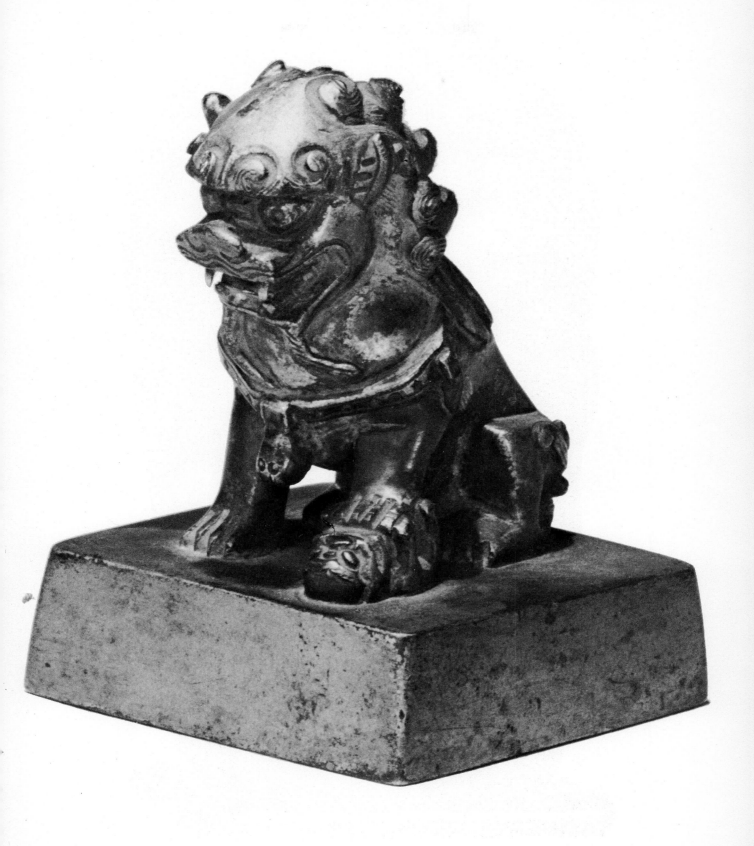

Lion. Gilt bronze. China, 15th century A.D. Height 2¼".
(Munsterberg Collection, New Paltz, N. Y.; photo by Raphael
Warshaw)

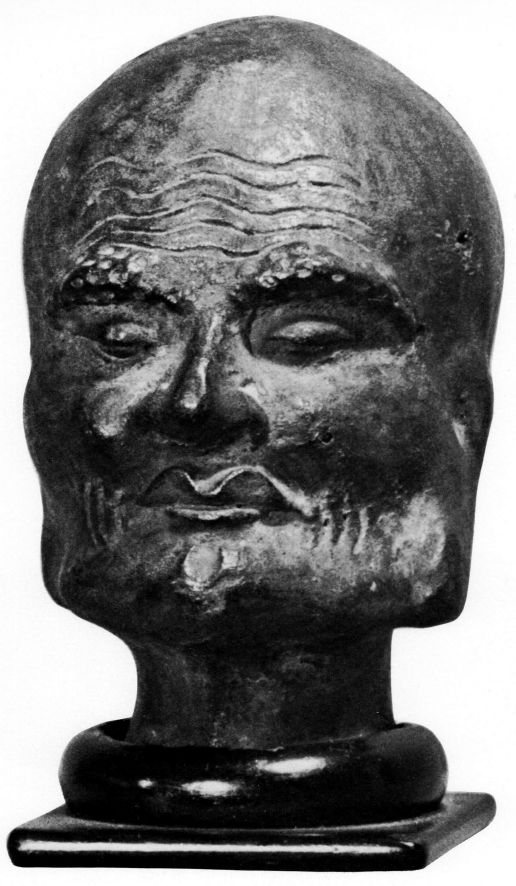

Head of an Arhat. Stone. China, 15th century A.D. Height 5½". (Haldeman Collection, Brookline, Mass.)

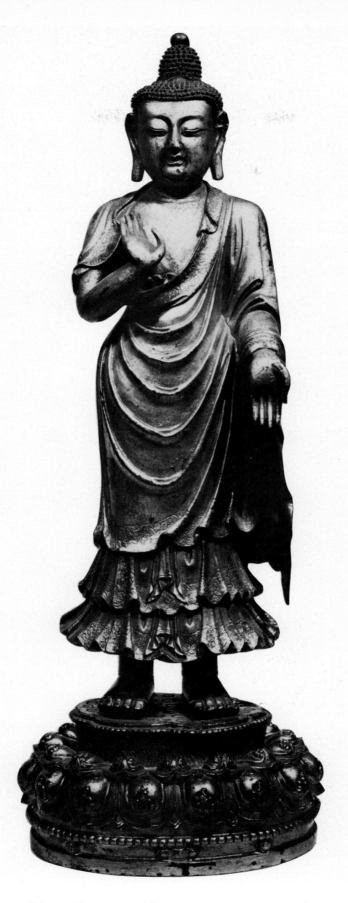

Buddha Amitabha. Gilt bronze. China, 16th century A.D.
Height 24". (Chait Collection, New York)

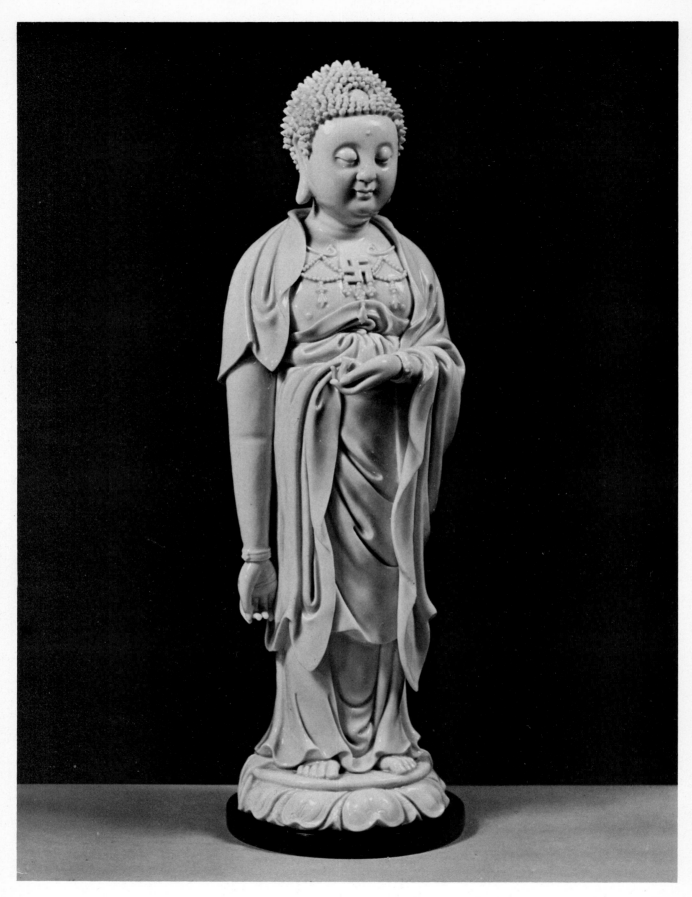

Standing Buddha. Porcelain. China, 17th century A.D. Height 19". (Morse Collection, New York)

Opposite: Reclining horse. Jade. China, 17th century A.D. Length 13½". (Morse Collection, New York)

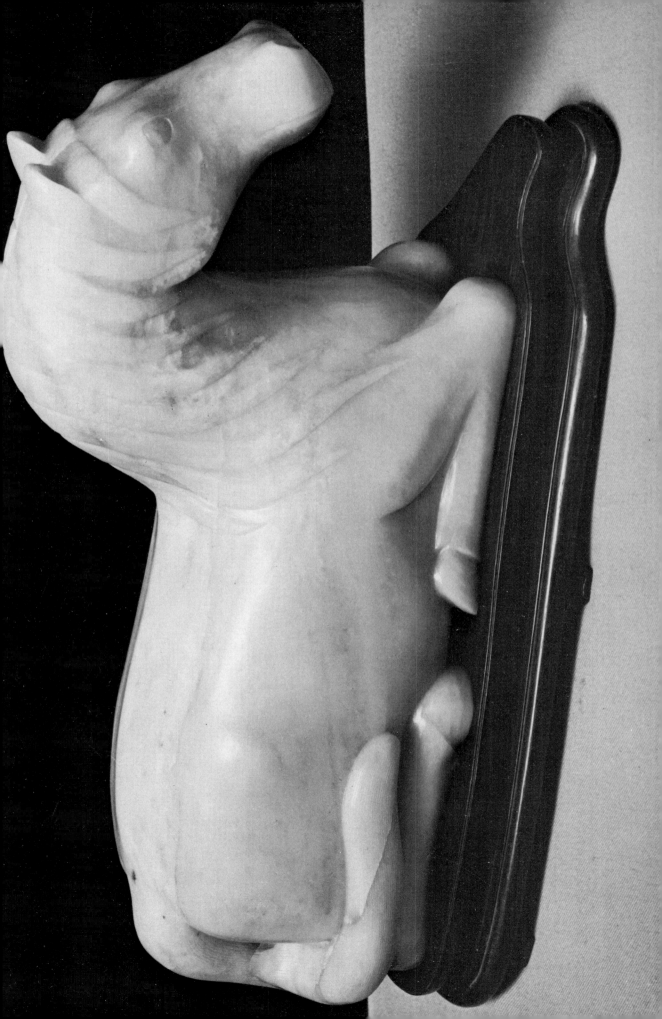

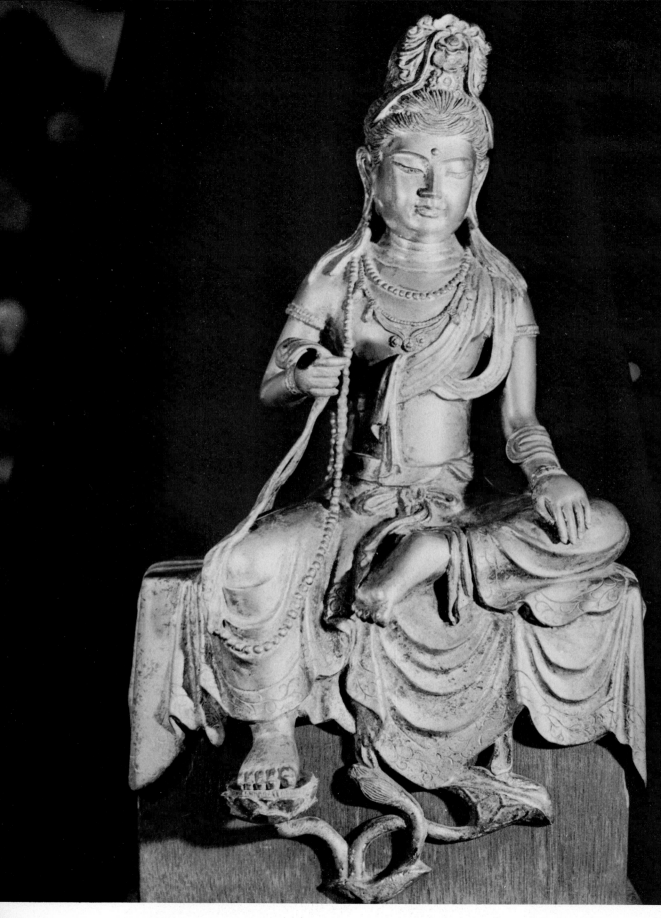

Seated Kuan Yin. Gilt bronze. China, 18th century
25". (Alsdorf Collection, Winnetka, Ill.)

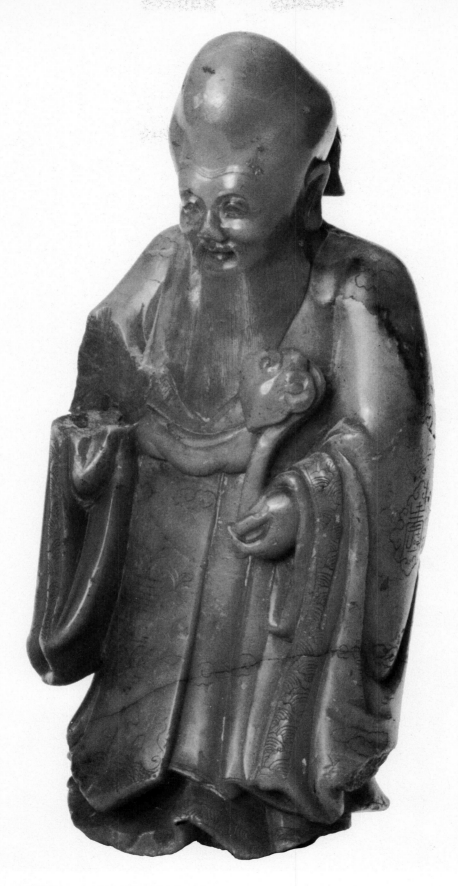

Taoist deity of long life. Soapstone. China, 18th century A.D. Height 9½". (Munsterberg Collection, New Paltz, N. Y.; photo by Raphael Warshaw)

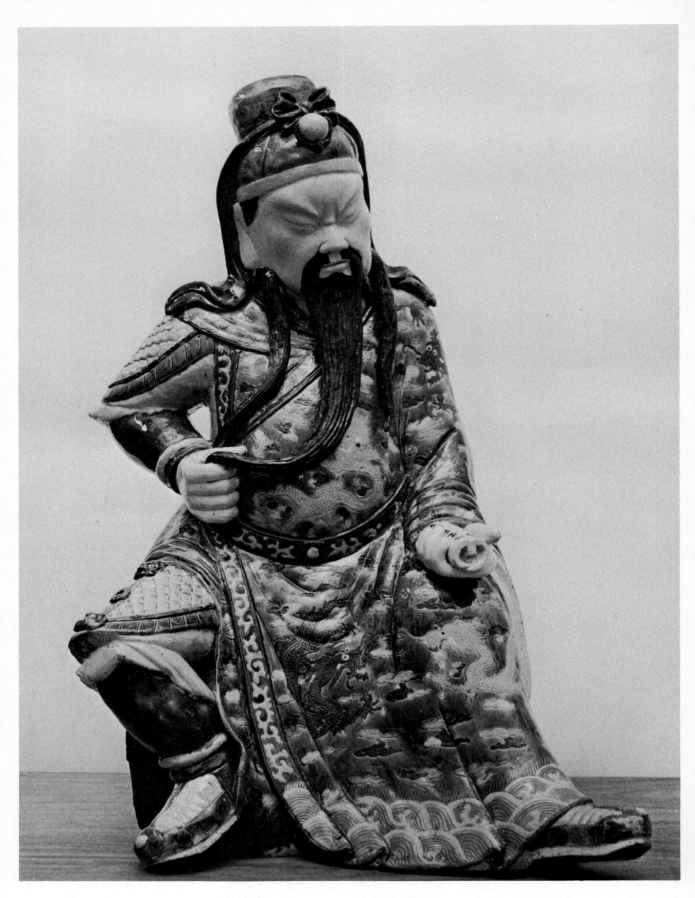

The god of war. Porcelain. China, 18th century A.D. Height 26". (William Wolff Collection, New York)

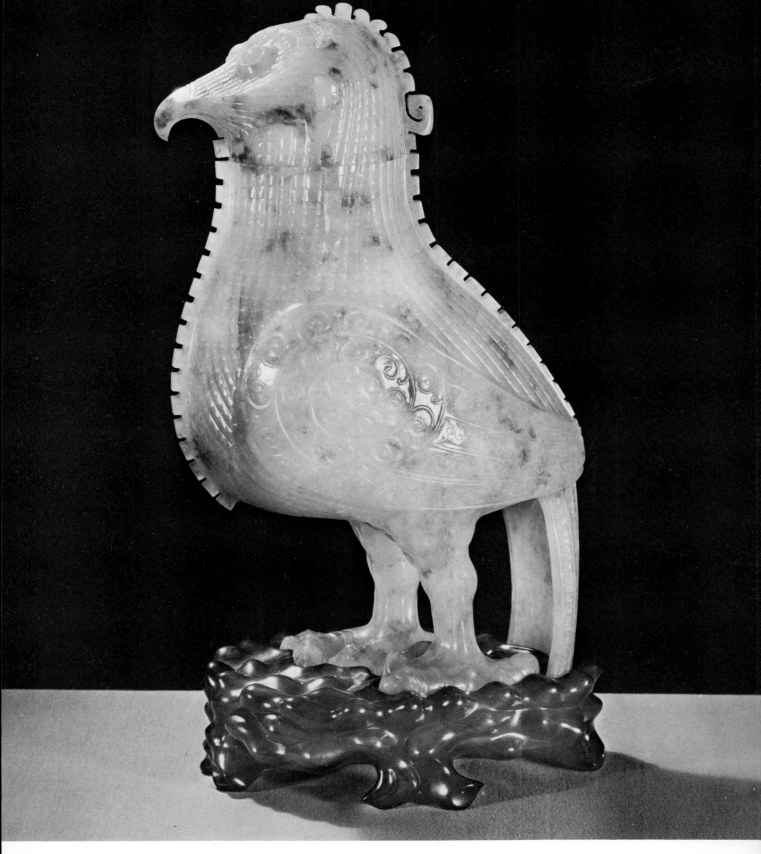

Owl. Jade. China, 19th century A.D. Height 14½". (Morse Collection, New York)

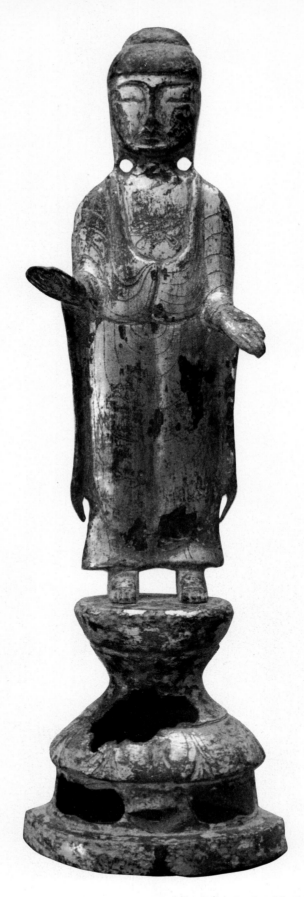

*Buddha Sakyamuni. Gilt bronze. Korea, 7th century A.D.
Height 7⅞". (Munsterberg Collection, New Paltz, N. Y.)*

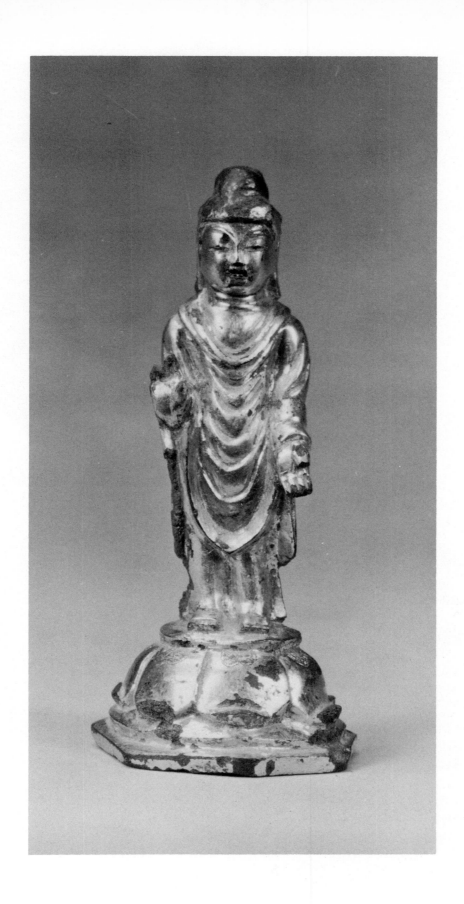

Buddha Sakyamuni. Gilt bronze. Korea, 8th century A.D.
Height 4''. (Private collection, Japan)

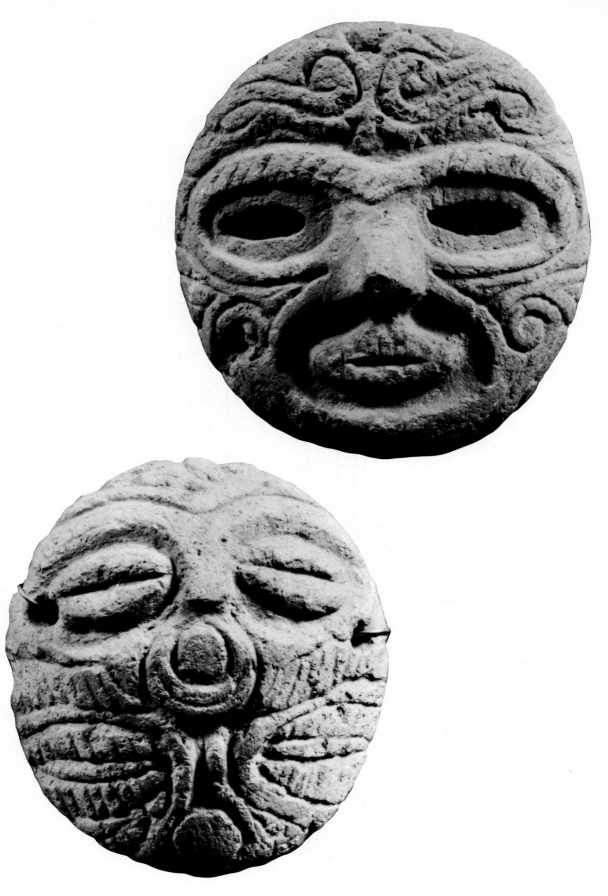

Jomon masks. Clay. Japan, 1st millennium B.C. Above: Height 2¼". (Leff Collection, Pittsburgh, Pa.) Below: Height 2¼". (Munsterberg Collection, New Paltz, N. Y.) (Photos by Thomas Feist)

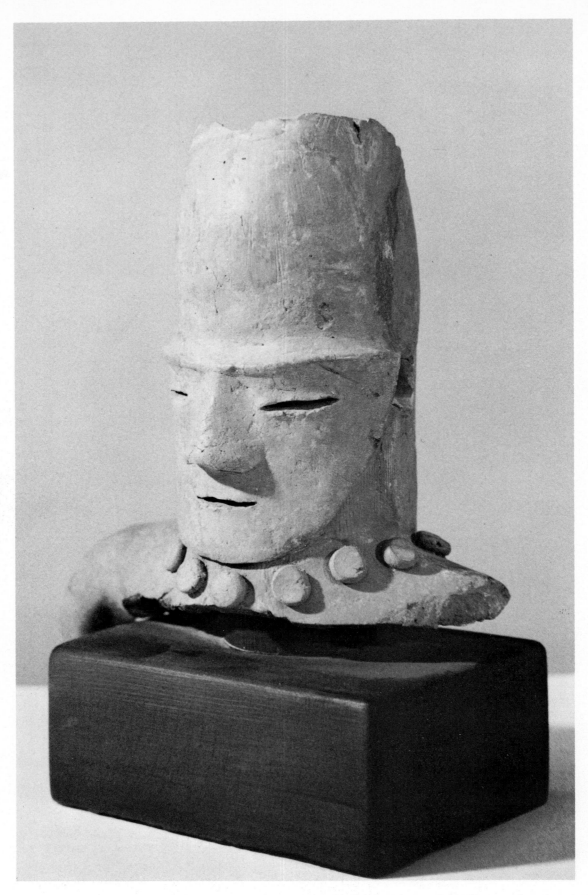

*Haniwa head. Clay. Japan, 5th century A.D. Height 7½".
(Munsterberg Collection, New Paltz, N. Y.)*

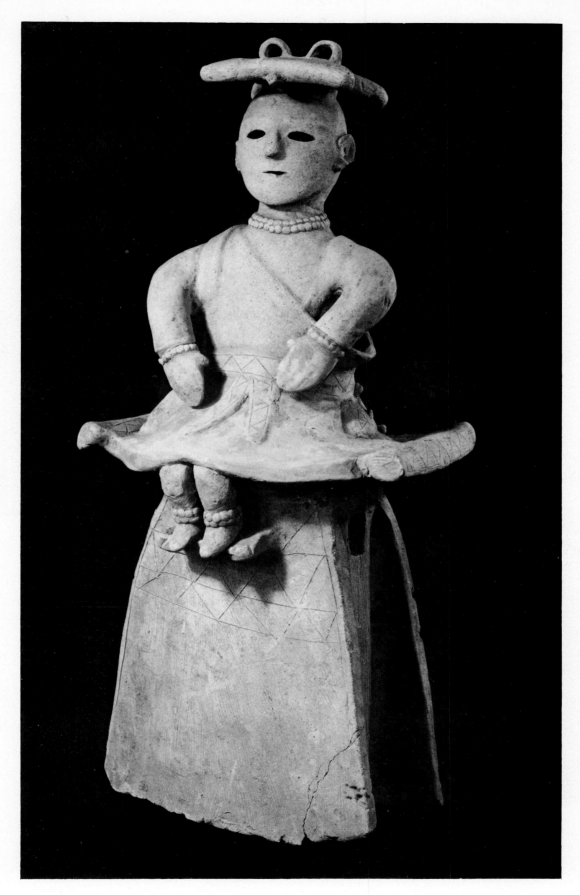

Haniwa figure. Clay. Japan, 5th century A.D. Height 24".
(Tokyo National Museum)

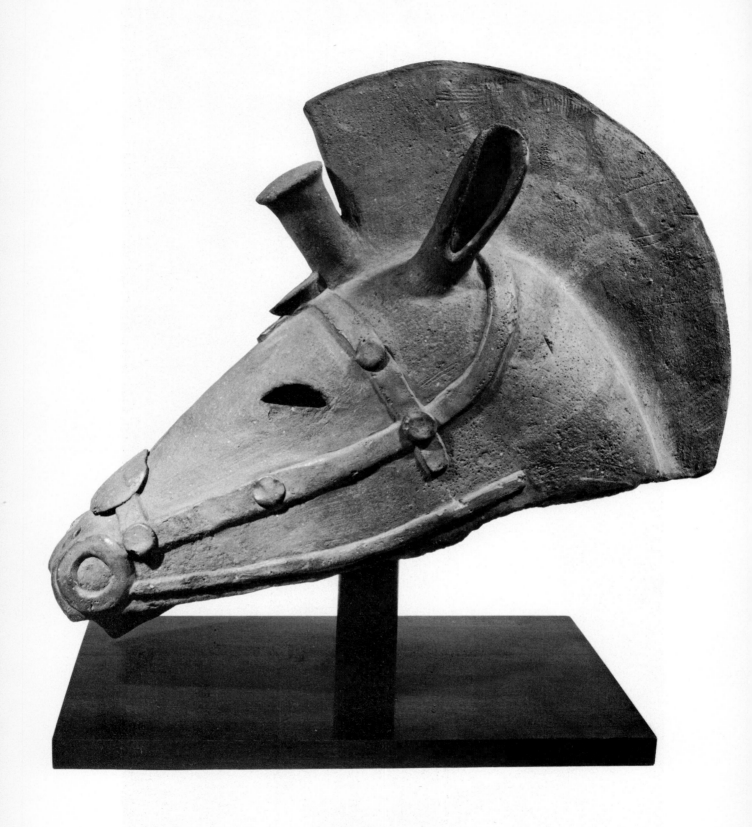

Haniwa horse. Clay. Japan, 6th century A.D. Height 16''.
(Chait Collection, New York)

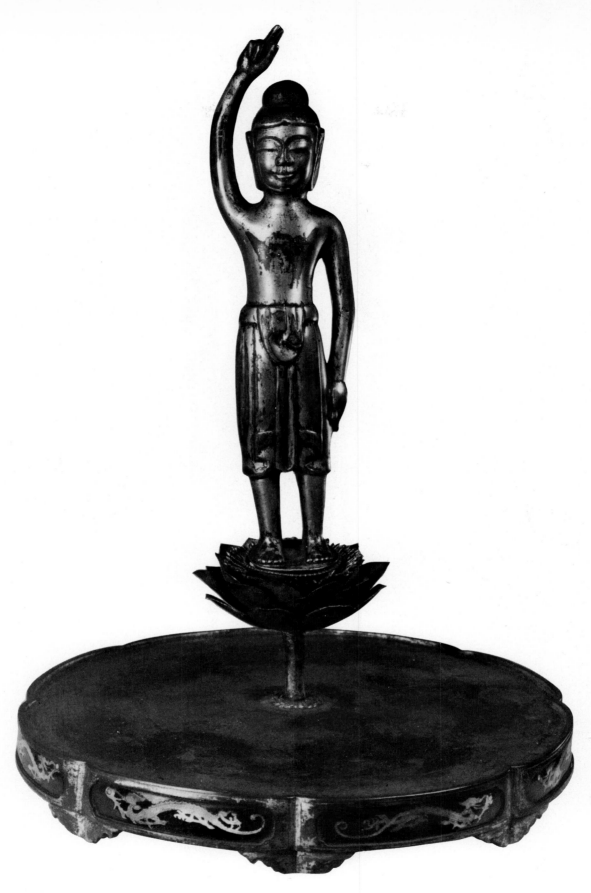

The infant Buddha. Gilt bronze. Japan, 7th century A.D.
Height 8⅜''. (Metropolitan Museum of Art, New York)

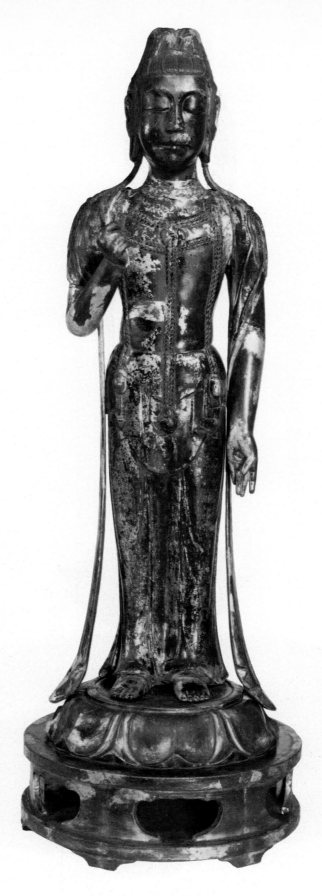

*Bodhisattva. Lacquered and gilt wood. Japan, 7th century A.D.
Height 37\frac{11}{16}". (Freer Gallery of Art, Washington, D. C.)*

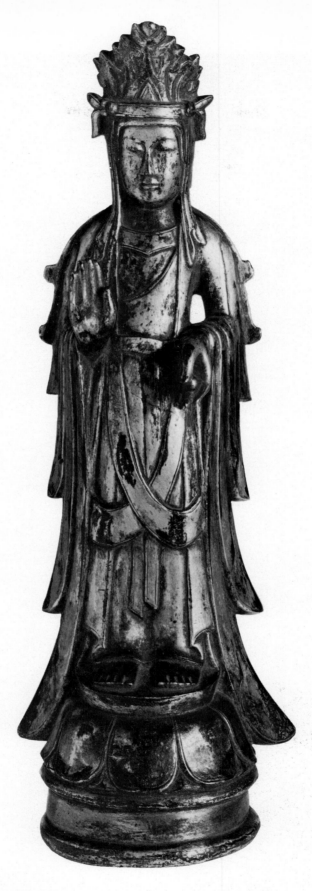

Bodhisattva. Gilt bronze. Japan, 7th century A.D. Height 13⁵⁄₁₆″. (Freer Gallery of Art, Washington, D. C.)

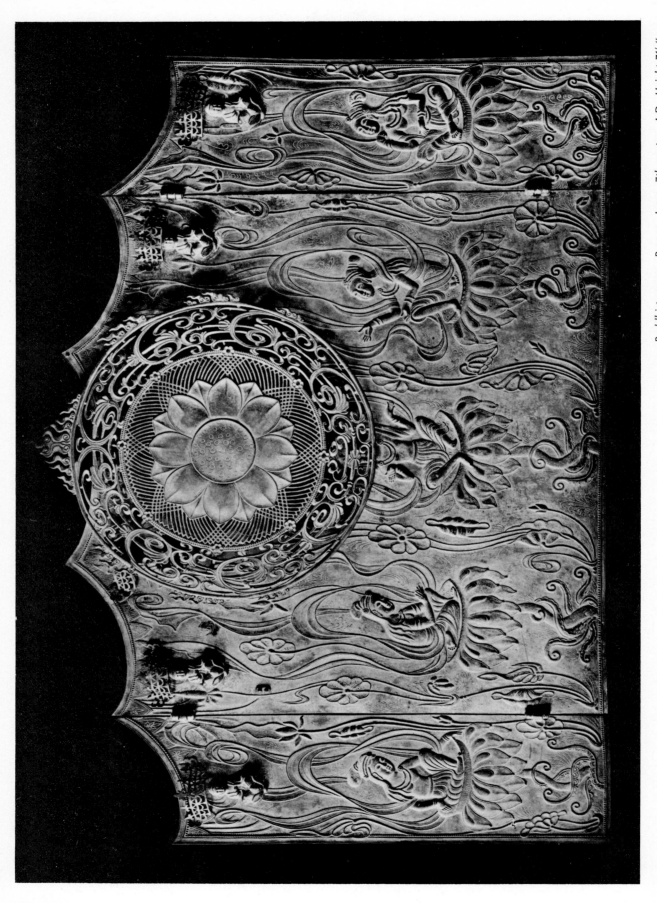

*Buddhist screen. Bronze. Japan, 7th century A.D. Height 7½".
(Horyuji, Nara)*

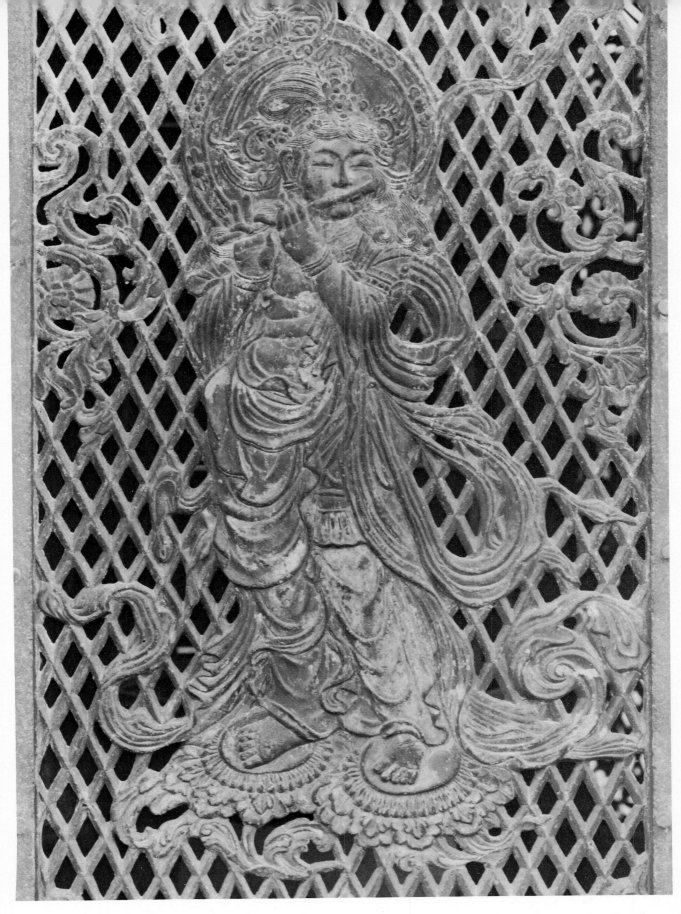

Heavenly musician. Bronze. Japan, 8th century A.D. Height 59½". (Todaiji, Nara; photo by M. Sakamoto)

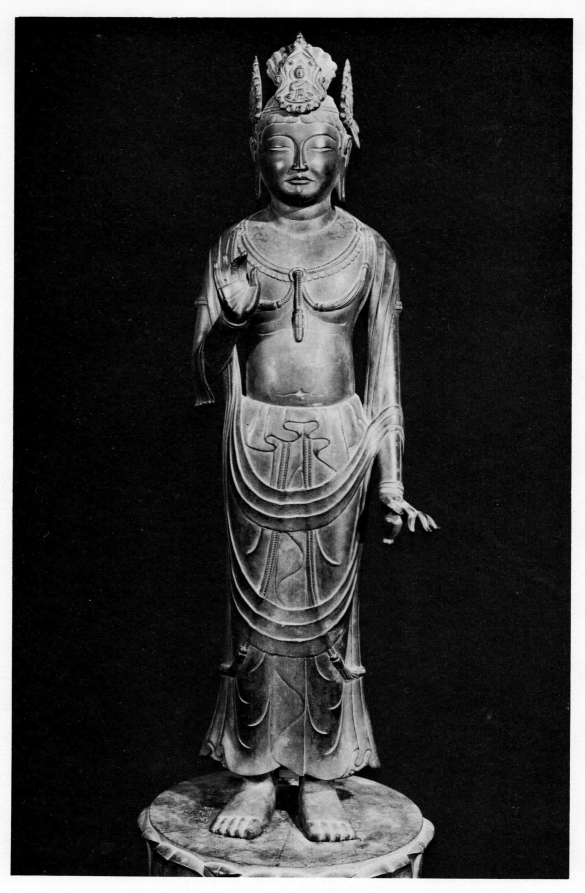

Kannon Bosatsu. Bronze. Japan, 7th century A.D. Height 29½". (Horyuji, Nara)

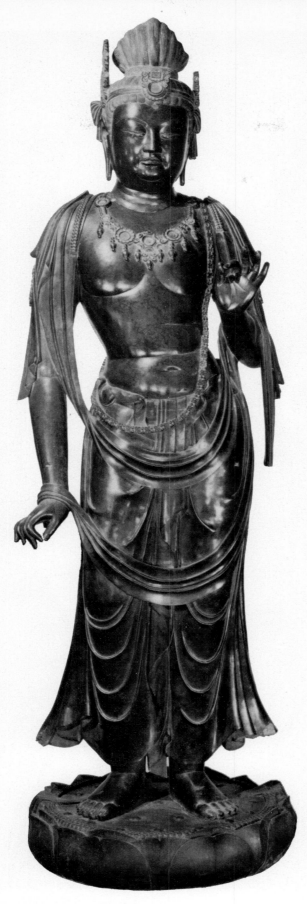

Gakko Bosatsu. Bronze. Japan, 8th century A.D. Height 11' 3".
(Yakushiji, Nara; photo by Rokumei-Sō)

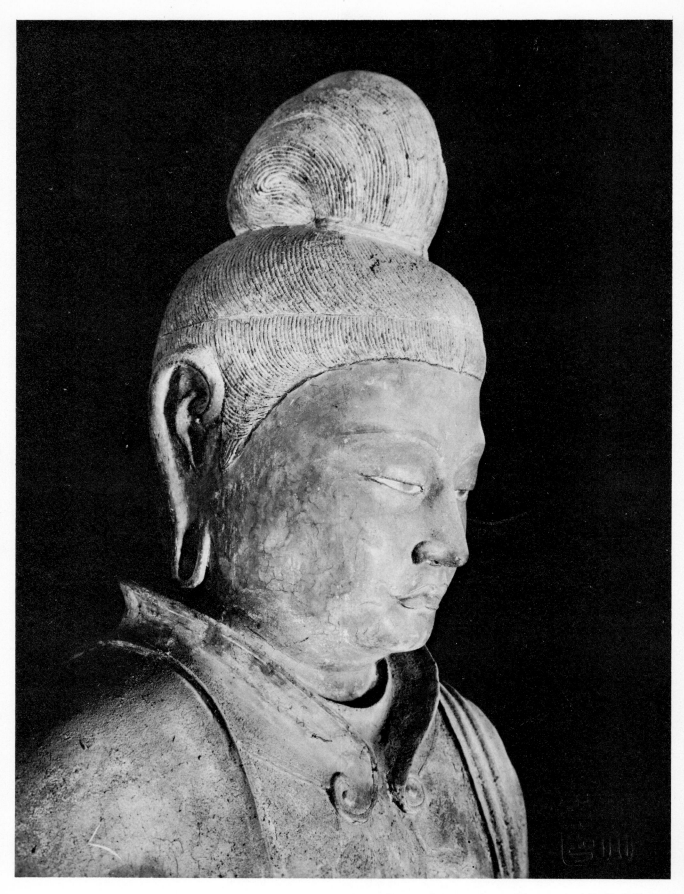

Bonten. Lacquer. Japan, 8th century A.D. (Todaiji, Nara)

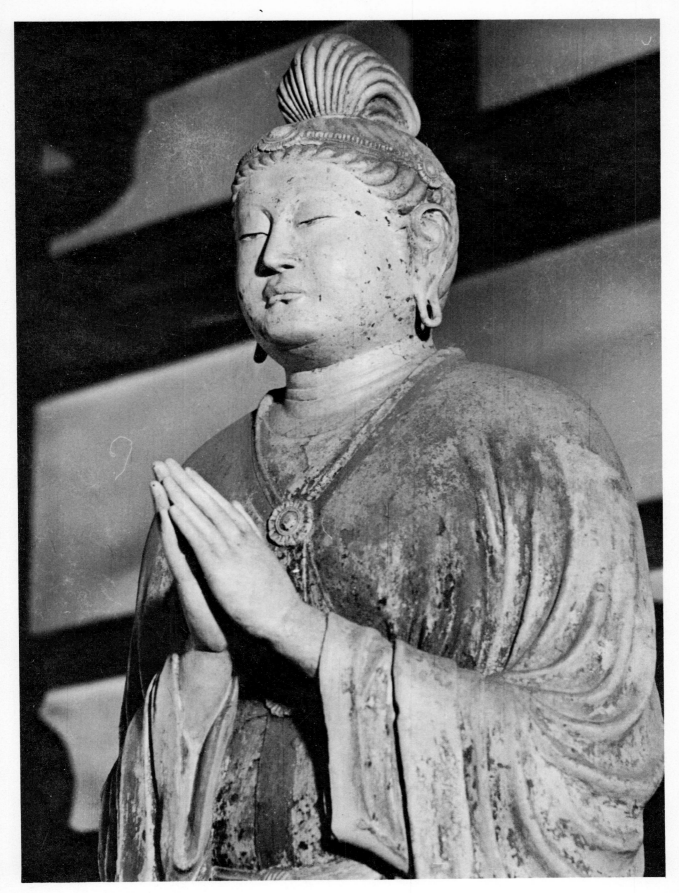

Gakko Bosatsu. Clay. Japan, 8th century A.D. Height c. 3'.
(Todaiji, Nara)

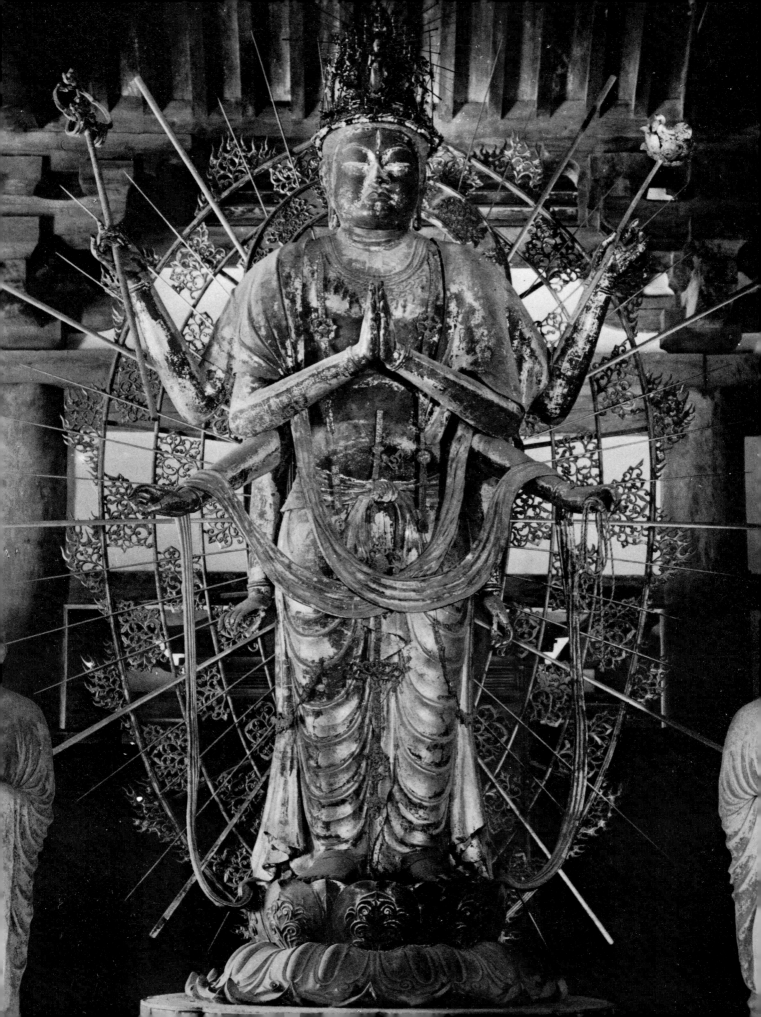

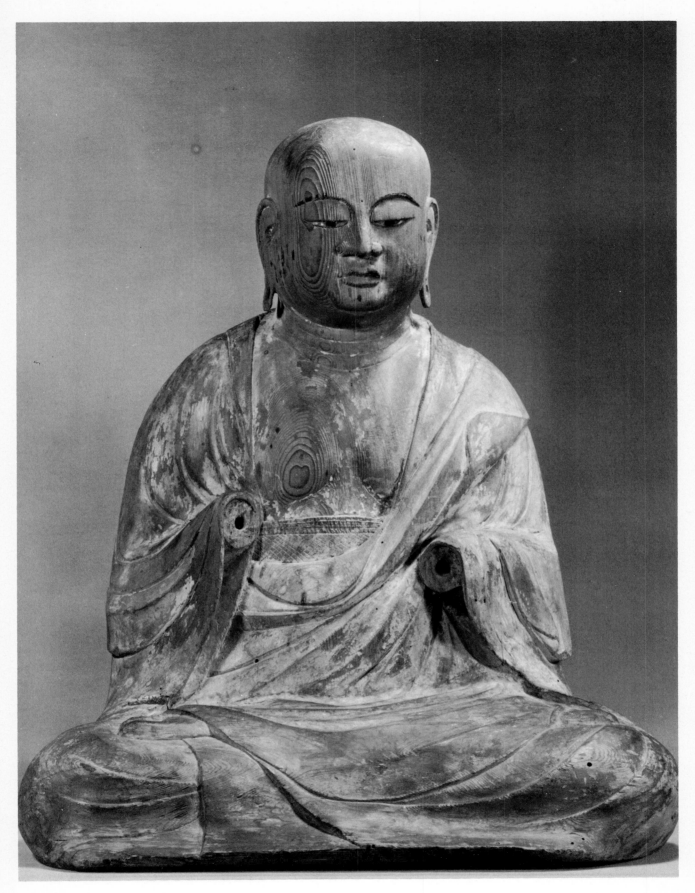

Sogyo Hachiman. Wood. Japan, 9th century A.D. Height
26½″. (Hollis Collection, New York)

Opposite: Many-armed Kannon. Lacquer. Japan, 8th century
A.D. Height 12′. (Todaiji, Nara; photo by Matsuyama-Roku-
meiyen)

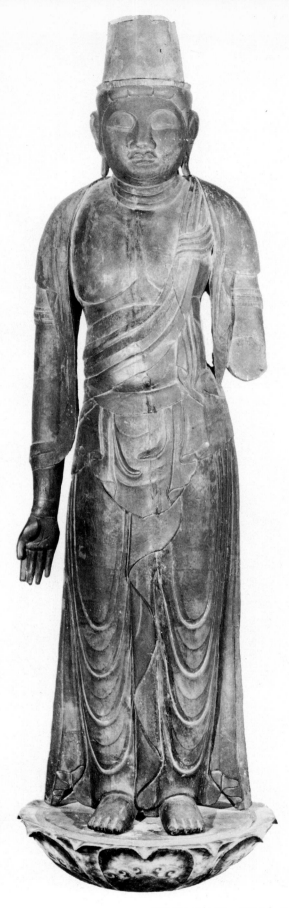

Kannon Bosatsu. Wood. Japan, 9th century A.D. Height 70½".
(William Rockhill Nelson Gallery of Art, Kansas City, Mo.)

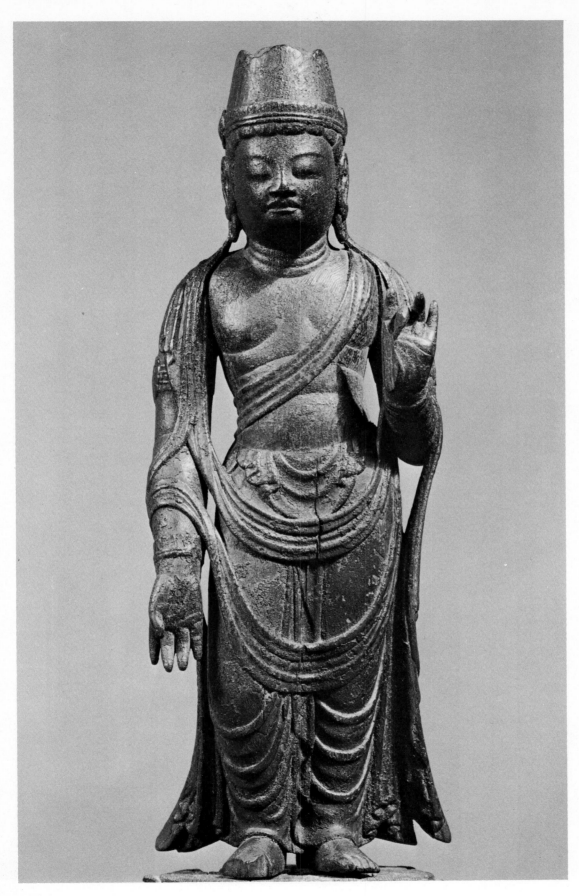

Kannon Bosatsu. Wood. Japan, 9th century A.D. Height 15½".
(Brooklyn Museum)

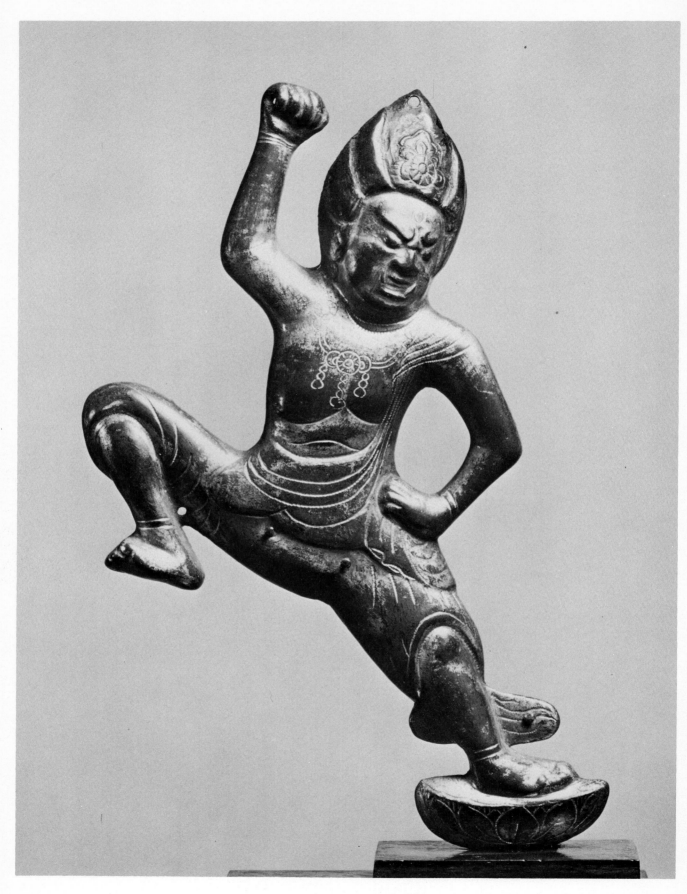

Zao Gongen. Gilt bronze. Japan, 12th century A.D. Height
6⅞". (William Wolff Collection, New York; photo by O. E.
Nelson)

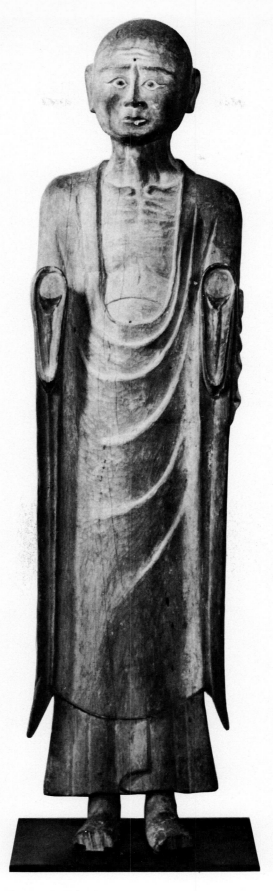

The priest Eji. Wood. Japan, 12th century A.D. Height 38"
(Martin Collection, New York; photo courtesy of The Brooklyn
Museum)

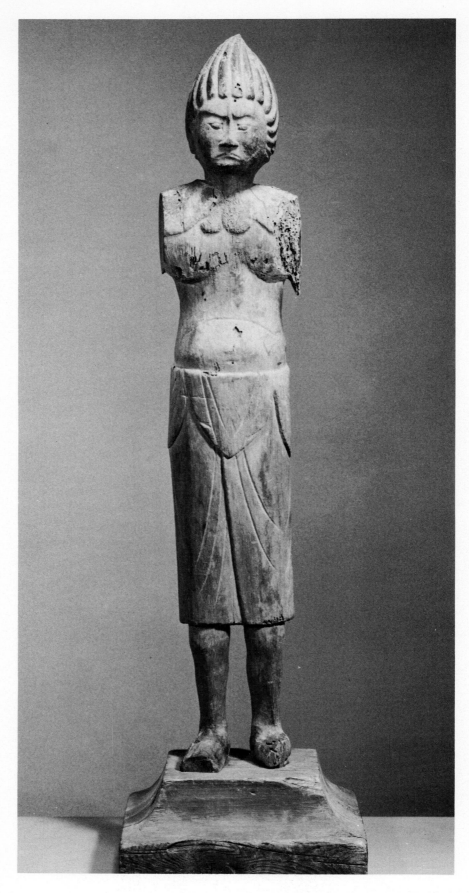

*Shinto deity. Wood. Japan, 12th century A.D. Height 45¼".
(Hollis Collection, New York)*

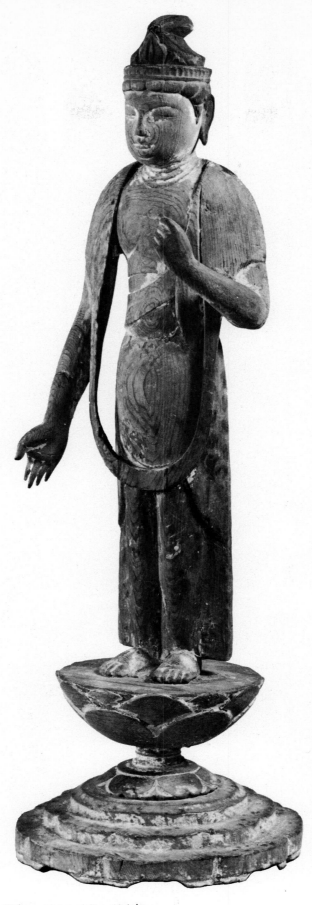

Kannon Bosatu. Wood. Japan, 12th century A.D. Height 18¾". (Brooklyn Museum)

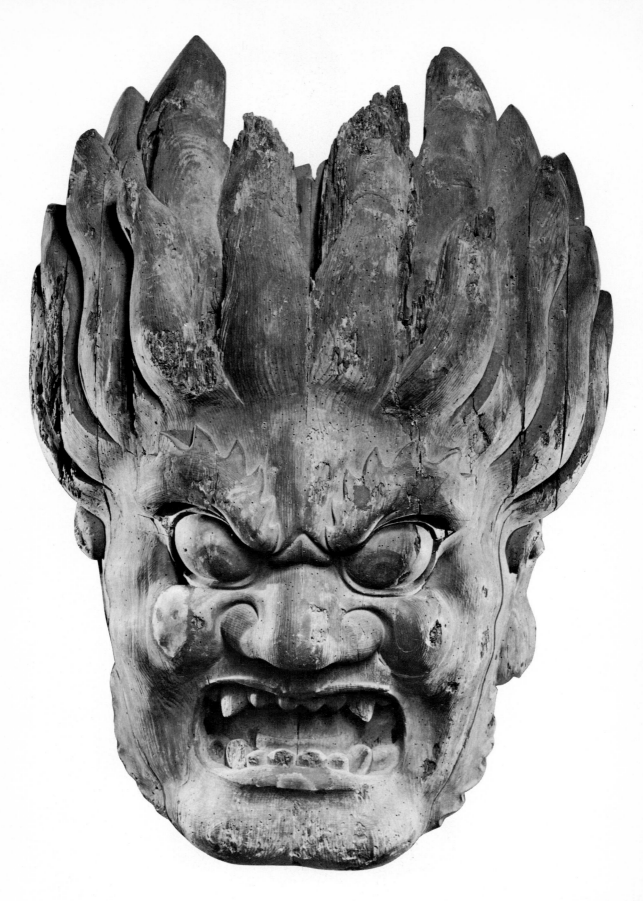

Head of a guardian. Wood. Japan, 13th century A.D. Height 48½". (William Rockhill Nelson Gallery of Art, Kansas City, Mo).

Opposite: Fudo. By Kakei. Wood with glass inlay. Japan, 13th century A.D. Height 20¾". (Hollis Collection, New York)

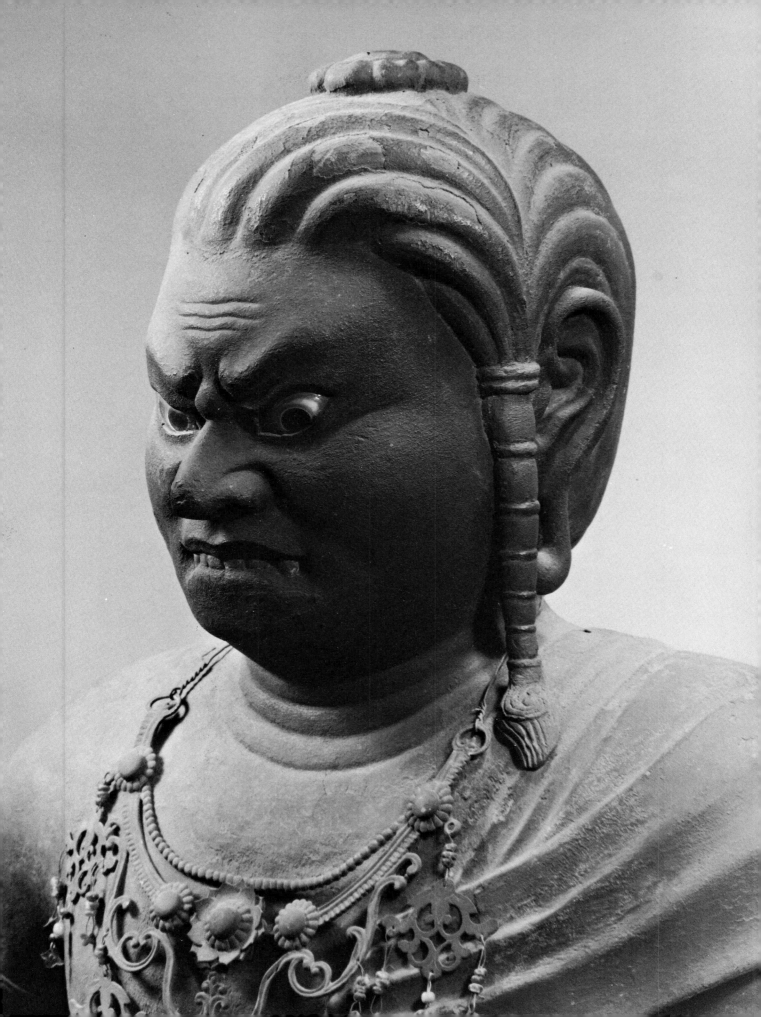

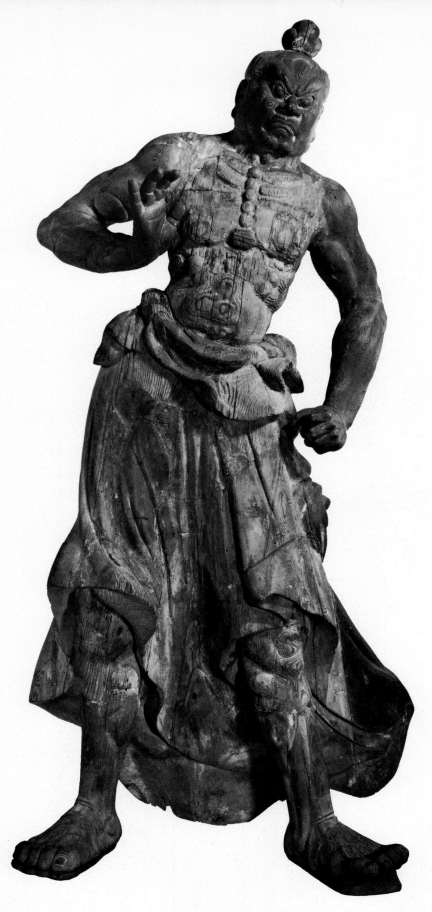

Guardian. Wood. Japan, 13th century A.D. Height 89⅛".
(Freer Gallery of Art, Washington, D. C.)

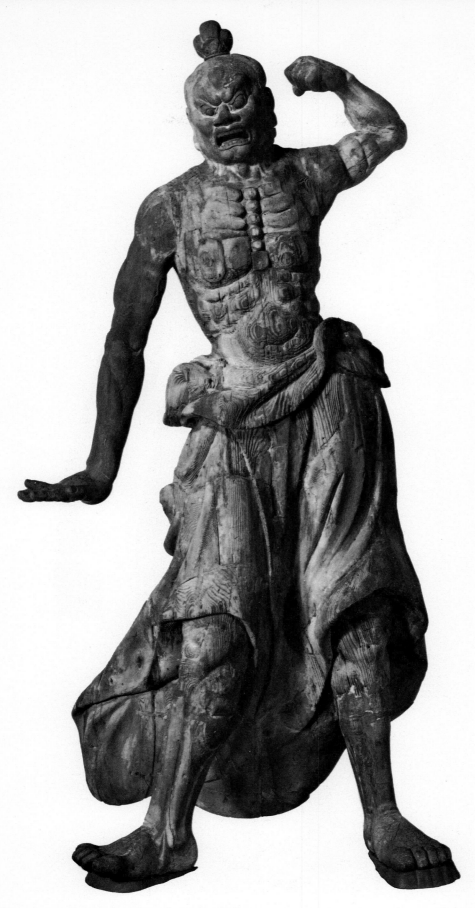

Guardian (forms a pair with No. 140). Wood, Japan, 13th century A.D. Height 92''. (Freer Gallery of Art, Washington, D. C.)

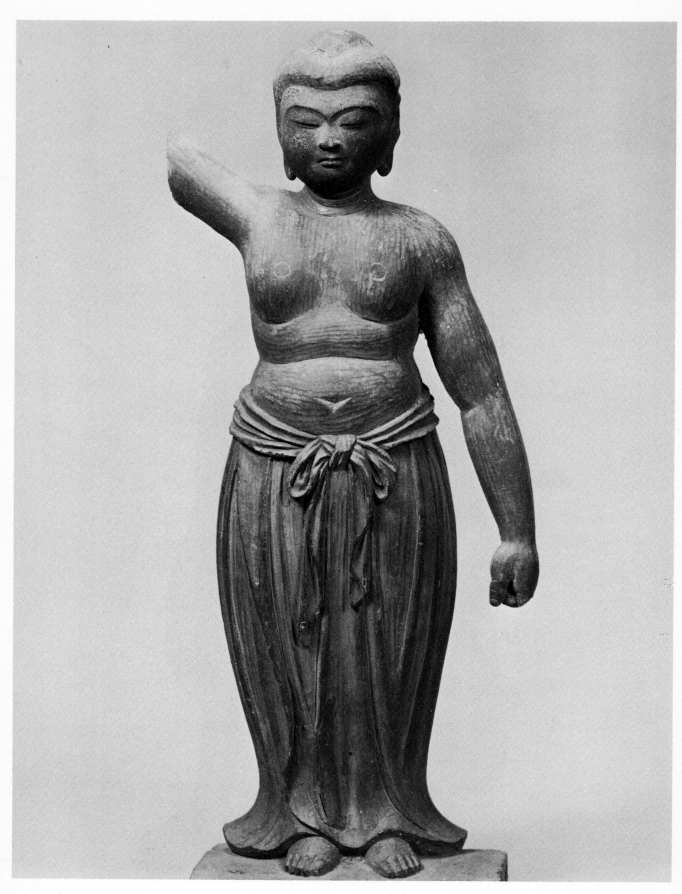

Tanjo Butsu. Wood. Japan, 13th century A.D. Height 10¾".
(Hollis Collection, New York)

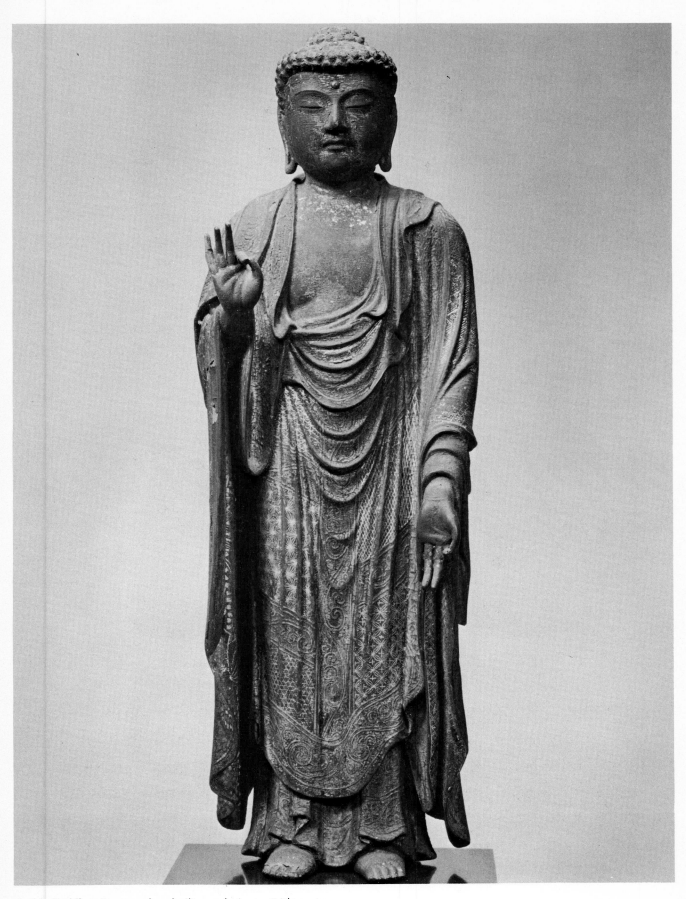

Amida Buddha. Lacquered and gilt wood. Japan, 14th century A.D. Height 13¼". (Hollis Collection, New York)

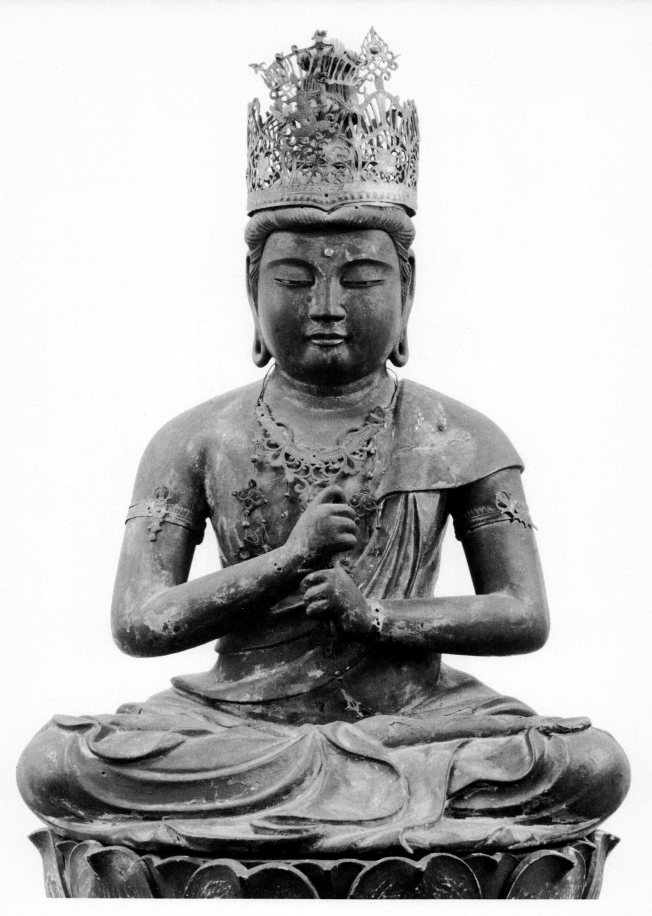

Dainichi Buddha. Lacquered wood. Japan, 14th century A.D. Height 20". (Hollis Collection, New York; photo by Charles Uht)

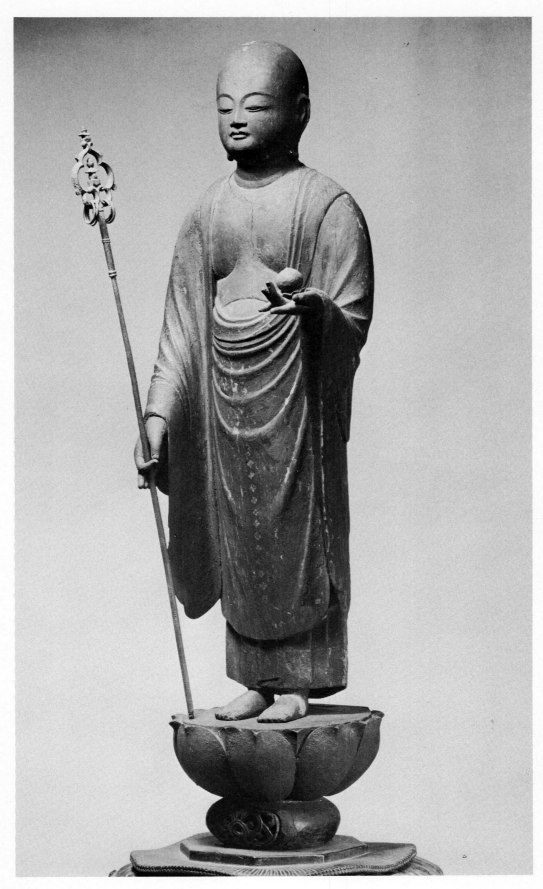

Jizo Bosatsu. Lacquered wood. Japan, 13th century A.D. Height 28½″. (Dickes Collection, Brooklyn; photo by O. E. Nelson)

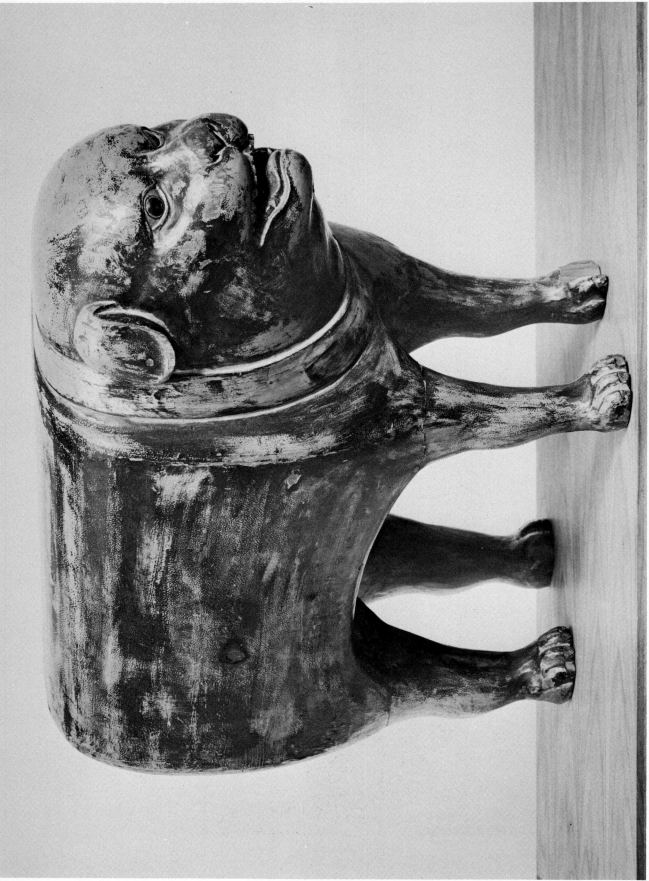

Temple dog. Lacquered wood. Japan, 15th century A.D. Height 19". (Hollis Collection, New York; photo by Charles Uht)

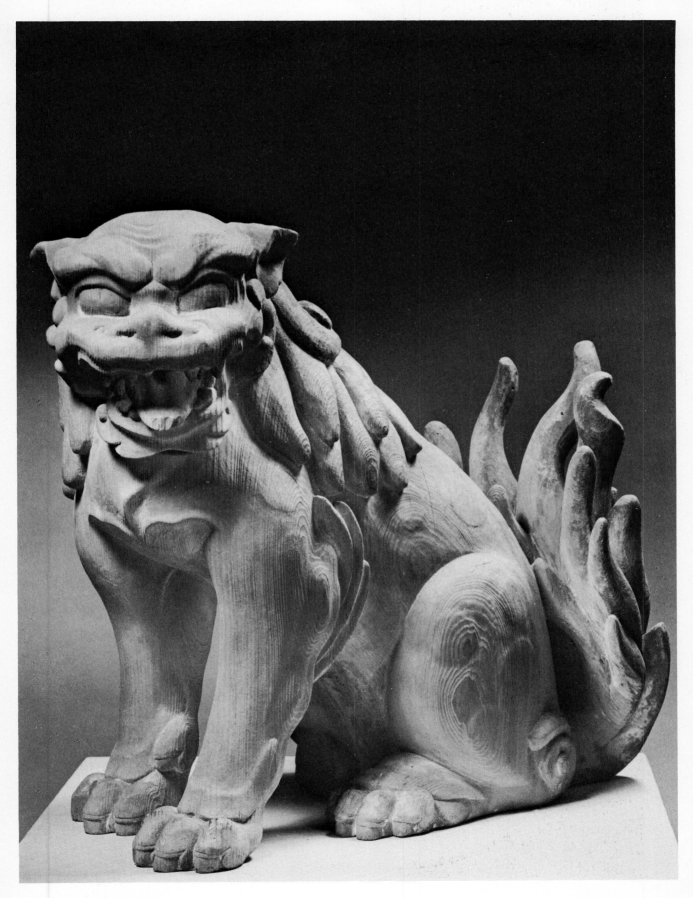

Temple lion. Wood. Japan, 15th century A.D. Height 12½".
(William Wolff Collection, New York; photo by O. E. Nelson)

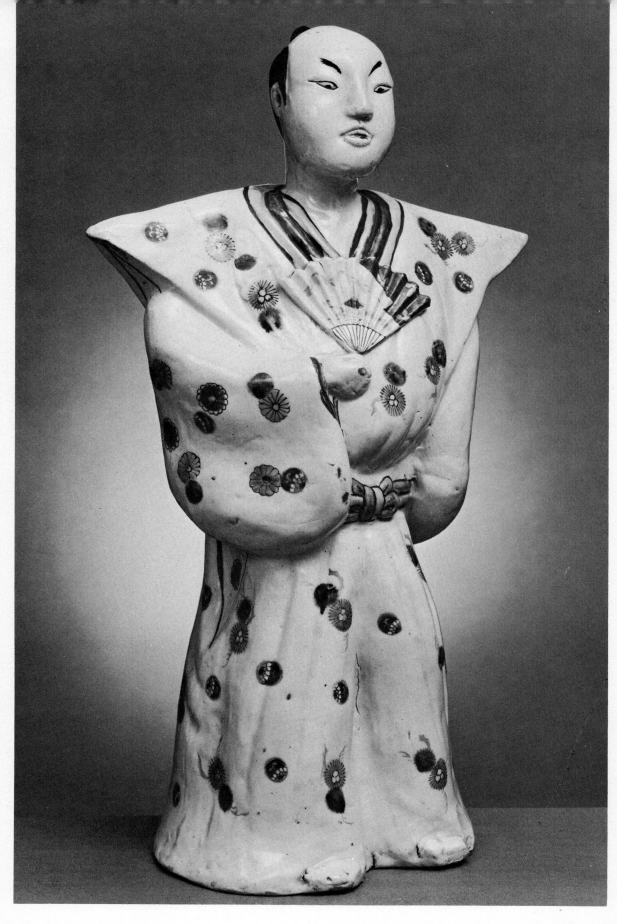

Kabuki actor. Porcelain. Japan, 18th century A.D. Height 16".
(Blumenthal Collection, New York; photo by Taylor & Dull)
Opposite: Folk sculpture of Michizane. Wood. Japan, 18th
century A.D. Height 6¾". (Brooklyn Museum)

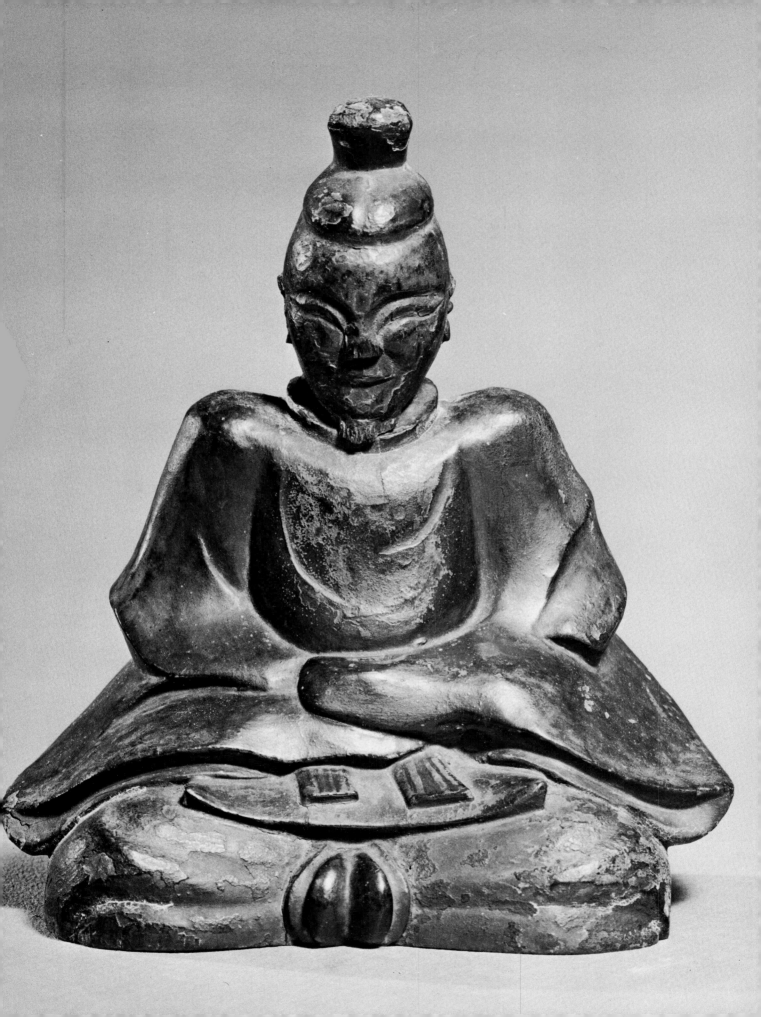